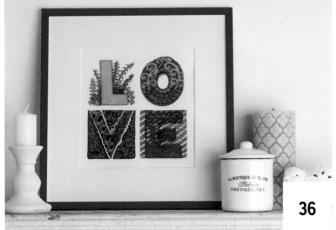

8

Projects

36

Patterns

40

66

Welcome!

"What a riot of color!" was my first thought when I walked into the medical clinic run by my brother- and sister-in-law in the mountains of Guatemala this November. It had been more than a decade since we had adopted our daughter, Hannah, from Guatemala, and with all the recent work around coloring and design that we have been doing with Design Originals, the colors, especially the women's intricately woven garments, struck me in a way that they hadn't before. During our visit, Hannah and I hiked a volcano, visited beautiful Lake Atitlan, and stayed in the historic city of Antigua; but the highlight for both of us was interacting with the wonderful people—including coloring and doing Zentangle with them—and seeing their artistic talents.

With so much happening in the world, it's comforting to know that we can still find connections in color and creativity. Take Angela Van Dam, for example. She is a wonderful new talent hailing from New Zealand. She goes by the name of Hello Angel; perhaps you have seen her on Instagram, Pinterest, or Facebook. We have been completely mesmerized by her intricate patterns and vivid colors and think you will be as well! Be sure to check out the article about her inside to see her beautiful artwork and learn some of her best coloring techniques.

Inside this issue you will find many ways to celebrate connections with your own circle of family and friends. From handmade valentines to creative Easter eggs and more, we hope that you too can share your love of crafting and coloring with your friends, whether they live right down the street or thousands of miles away.

Carole ☺

Carole Giagnocavo, Publisher

I DO craft!
DO Magazine is all about doing! Draw and color on these pages, tear out the coloring sheets, make something—have fun! Say, I AM creative, I DO craft!

See pictures from our Guatemala trip on page 66 and at *www.domagazines.com!*

DO magazine
COLOR TANGLE CRAFT DOODLE

Design Originals Presents DO Magazine, Winter/Spring 2016
Volume 2, Number 1, Issue 3 | www.domagazines.com

Design Originals: DO Magazine – Color, Tangle, Craft, Doodle
1970 Broad Street, East Petersburg, PA 17520
Phone: 717-560-4703 | Fax: 717-560-4702

Our Mission: To promote coloring, drawing, pattern ornamentation, and tangling for enjoyment and health

PUBLISHER	Carole Giagnocavo
ASSOCIATE PUBLISHER	Peg Couch

CONTRIBUTORS

Brenda Abdoyan	Thaneeya McArdle
Amy Anderson	Valerie McKeehan
Sandy Steen Bartholomew	Suzanne McNeill
Kati Erney	Llara Pazdan
Joanne Fink	Robin Pickens
Carole Giagnocavo	Deb Strain
Valentina Harper	Debra Valencia
Ben Kwok	Angela Van Dam
	Jess Volinski

EDITORIAL STAFF	Peg Couch
	Colleen Dorsey
	Katie Weeber
	Kati Erney
LAYOUT AND DESIGN STAFF	Ashley Millhouse
	Llara Pazdan
PROJECT DESIGN	Peg Couch
	Llara Pazdan
	Kati Erney

This book is printed on paper produced from trees harvested from WELL-MANAGED Forests where measures are taken to protect wildlife, plants, and water quality.

Customer Service for Subscribers
Visit www.domagazines.com, call 800-457-9112, or write: DO Magazine, 1970 Broad Street, East Petersburg, PA 17520

Newsstand Distribution: Curtis Circulation Company
Circulation Consultant: National Publisher Services
Printed in USA.
©2016 by New Design Originals, Inc. All Rights Reserved.

Subscription rates in US dollars:
One year $39.95
Canada | One year $44.95
International | One year $49.95
Wholesale/Distribution
DO Magazine: Color, Tangle, Craft, Doodle is available to retailers for resale on advantageous terms. Contact Sales Support for details: 800-457-9112 Ext. 105 or sales@foxchapelpublishing.com.

Identification Statement: DO Magazine (Winter/Spring 2016) vol. 2, no. 1
DO Magazine is published quarterly by Fox Chapel Publishing Co. Inc., 1970 Broad Street, East Petersburg, PA 17520
POSTMASTER: Send address changes to DO Magazine, 1970 Broad Street, East Petersburg, PA 17520.
Note to Professional Copy Services — The publisher grants you permission to make up to ten copies for any purchaser of this magazine who states the copies are for personal use.

This Is How We DO

DO Magazine and Design Originals love to share with friends all around the world! Check out some pics of what we've been up to.

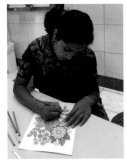
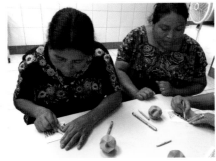
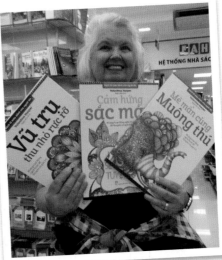

Copies of *DO Magazine* and several Design Originals coloring books made their way to Guatemala with publisher Carole Giagnocavo, where they were a big hit with mothers and children. She also taught a group of Mayan women how to make the paper ball from issue #2 of the magazine—to great success!

Author and *DO Magazine* contributor Suzanne McNeill visited Vietnam this past summer and said that coloring books were everywhere. "I saw them at bookstores in Hanoi and Saigon, and even found some books by Design Originals! So exciting to see DO books around the world," she said. The three books in this photo are all by Valentina Harper—see page 38!

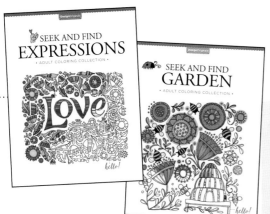

So Fun: Seek and Find!

We have the next great thing in coloring for you: seek and find coloring pages! With Robin Pickens' fun new concept, not only do you get an abundantly designed and beautiful page to fill with vibrant color, but you also get to enjoy the thrill of the hunt as you search for one small icon within each page. Do your best to find this little ladybug in the sample design on page 31, and look for Robin's new books, available spring 2016!

Send Us Your Work!

Email or mail us your awesome finished pieces from the magazine (or photos of your crafty work) and we might just feature you in a future issue! If we feature you, we'll send you an awesome surprise. Send your work to editor@foxchapelpublishing.com or to DO Magazine, 1970 Broad Street, East Petersburg, PA 17520, and don't forget to include your contact info!

"Happy Holidays from The Janus School! The students and I want to **thank you** for including us in the *DO Magazine*. We enjoyed the interview process and our mock photo shoot. Every Monday is Mandala Monday in the art room and the coloring books that you left behind are used frequently. **We have even started trying to draw our own coloring pages!** Thank you for thinking of us for your article and we wish you a Merry Holiday Season."
—Beth Lehman and the art students at The Janus School, an independent academy in Pennsylvania for children with learning differences (check out the article featuring Beth and her students, "Color Me Happy", in DO Magazine Issue 2).

Easy, Elegant EASTER EGGS

Who said Easter eggs were just for kids? Here are four ways to make stylish, seasonal eggs that are a far cry from the food-coloring versions we all made as kids.

Zentangle

You can use the Zentangle method (see page 14) on any surface—even a round one! These eggs were decorated using fine-point markers (Sharpie) for details, white gel pens (Gelli Roll by Sakura), and an oil-based paint pen (Sharpie).

Tie-Dyed

This technique is pure magic!

Materials

- **100% silk patterned tie, scarf, or other disposable silk fabric (darker colors are best)**
- **Lightweight, light-colored or white fabric scraps (such as an old pillowcase)**
- **String or twist ties**
- **¼ cup (60ml) vinegar**
- **Eggs**
- **Pot/saucepan**

1. Prep the fabric. Cut a piece of the silk fabric and the lightweight fabric each large enough to completely cover an egg, one of each for each egg you are making. **2. Add the silk fabric.** Wrap the eggs with the printed side of the silk fabric on the egg. Wrap it tightly—tighter wrapping makes a better pattern imprint—but don't break the eggs. Once each egg is wrapped, tie the fabric securely with string or a twist tie. **3. Add the light fabric.** Next, wrap each egg again, this time with the lightweight fabric, and tie it off. **4. Boil the eggs.** Cover the eggs with water and ¼ cup (60ml) of vinegar in a pot, bring to a boil, and boil for about 20 minutes. After they are done, allow them to cool and then remove the fabric.

Thread-Wrapped

These modern eggs are much easier to make than they look.

Materials

- **Embroidery floss**
- **Fabric stiffener**
 (such as Stiffy by Plaid)
- **2 small bowls**
- **1 package of 3" (7.5cm) water balloons**

1. Prep your surface. Cover your work area with a protective layer such as plastic wrap; avoid newspaper as the fabric stiffener can make newspaper ink bleed. **2. Start the egg.** Blow up a balloon to the desired size. Pour some fabric stiffener in a bowl, dip some embroidery floss (still attached to the spool/bundle) in the mixture, and begin to wind it around the balloon. **3. Wrap the egg.** Wrap the entire balloon with floss, making sure that it goes in different directions like a ball of yarn. The less you wrap, the lacier it will look; the more you wrap, the sturdier the egg will be. **4. Finish the egg.** Let the egg dry overnight in a bowl so it doesn't stick to any surfaces. When it is dry and stiff, pop the balloon and remove it from inside the egg.

Don't eat eggs that you've colored! The ink or dye can seep into the egg and is not healthy to consume.

Tip! For extra pizazz, try threading beads onto the thread as you wind it around the egg—you will add amazing shine and texture!

Hand Lettering

Using a plain alcohol-based marker (such as a Sharpie), you can turn a blank egg into a beautiful message with handwritten words and doodles. Markers come in all sizes, allowing you to make your script as thin or as bold as you like.

QUIZ:
What's Your Springtime Style?

Ready to start decorating your home and getting crafty this spring, but don't quite know where to start? Take this quiz to find out what springtime coloring scheme best matches your personality, and take it from there!

What Springtime Color Scheme Are You?

BY KATI ERNEY

Spring is right around the corner— what is your favorite part of the upcoming season?

a I love all of the opportunities I get to show my family how much they mean to me!

b There's nothing better than afternoon strolls through the park.

c Picnics! Garden parties! Outdoor adventures!

d Hello, Daylight Savings time! I can't get enough sunshine.

You know what they say: April showers bring May flowers! During those pesky bouts of rain, you can be found...

a Baking something sweet and special for my loved ones.

b Cuddled up by the open window with my favorite book.

c Dancing barefoot in the rain... a little drizzle won't dampen my fun!

d Using all of my brightest markers to color in a new coloring book.

Pattern on page 17.

You're attending a garden party with all of your closest friends—what is your go-to drink?

a I love a good glass of wine, any time.

b A specially made blueberry lemonade, please!

c Let's invent a new cocktail!

d Mimosas are a must.

You wouldn't dare leave the house this spring without:

a The cherry red lipstick I've been waiting all winter to wear.

b A soft, light scarf. It's still a little breezy out there.

c My black and white polka dot rain boots!

d My bright yellow umbrella, of course.

What do your friends and family love most about you?

a They say I have the biggest heart around.

b I'm quiet and gentle but the best friend on earth.

c My super unique personality!

d That I'm always wearing a smile.

If you chose MOSTLY A's: Your colors are **BOLD AND ROMANTIC!** You love the sentimental things in life and have a passionate personality. You enjoy anything that allows you to share your love with other people. Springtime style inspiration: A bouquet of roses. Blossoms of red, magenta, and pink with accents of white or light gray.

If you chose MOSTLY B's: Your colors are **SOFT AND SUBTLE!** You may be quiet, but you effortlessly excel at making everyone feel perfectly comfortable and happy. You count each day, rain or shine, as a blessing. Springtime style inspiration: A plush hydrangea bush. Soft palettes of light blue and lilac with a touch of pale chartreuse.

If you chose MOSTLY C's: Your colors are **FUN AND QUIRKY!** You are full of bold and entertaining energy. Your sense of humor and unique tastes inspire others. Nothing can discourage you from having a good time. Springtime style inspiration: A garden full of pansies. Bursts of purple, mulberry, and white with just a hint of yellow.

If you chose MOSTLY D's: Your colors are **BRIGHT AND WARM!** You are a ray of sunshine on a dreary day. You love being at the center of the group, radiating good times, and your spring is forever filled with joy. Springtime style inspiration: A path lined with daffodils. Splashes of bright yellow with accents of orange and white.

Bold & Romantic

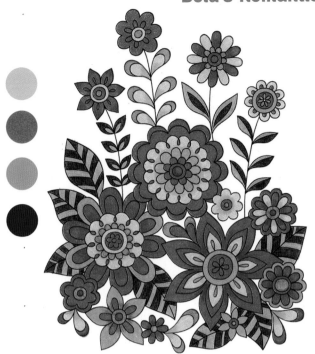

Soft & Subtle

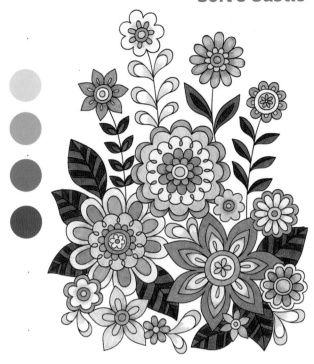

Fun & Quirky

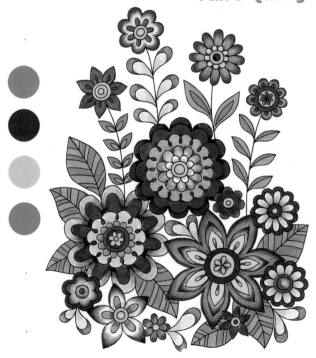

Bright & Warm

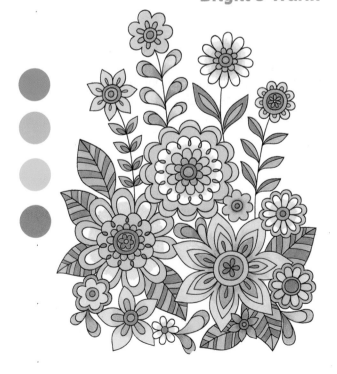

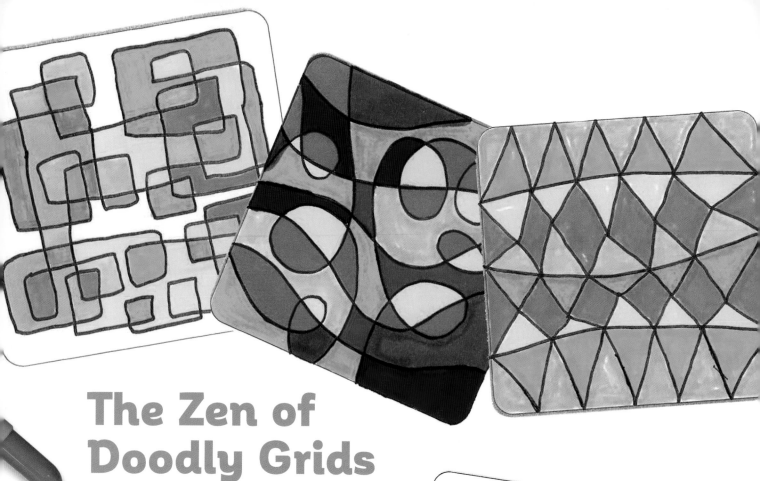

The Zen of Doodly Grids

BY SUZANNE MCNEILL

Daunting tasks must be broken into single steps—that's Problem Solving 101. So what does this have to do with art? Starting with a blank canvas, sheet of paper, or page in a sketchbook can be overwhelming. There's so much white space. By using "doodly grids" to break up the space, you can impose order, making it easier to decide what to put in each area. It's a classic "divide and conquer" approach. Individual areas of a grid become small steps. As you complete each section, you take another step. Before you know it, you have settled into the process, your creativity flows, and decisions about color and pattern come easily. You find your "Zen," one step at a time. So whether you are framing a photo, decorating a card, or simply want to make an easy new doodle, drawing a grid allows you to simplify the process and start creating faster and more confidently.

You Try!

Color and pattern the sample practice grids on page 19.

Look for a new book from Suzanne McNeill, coming in 2016, that features doodly grids as well as plenty of other ways to doodle and color for relaxation and enjoyment!

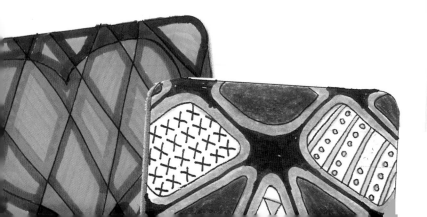

How to Make a Doodly Grid

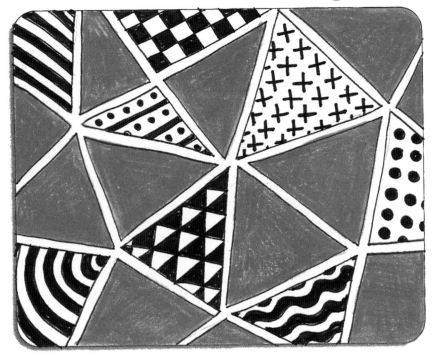

Breaking up a space makes it easier to fill with interesting colors and patterns. Use this basic grid technique to open up new design possibilities.

1 Lightly draw a triangular grid with a pencil. Don't stress—it shouldn't look perfect!

2 Draw a triangle in each section with pen, then erase the pencil lines.

3 Add stripes to the grid lines.

4 Fill in alternating spaces on the grid lines with black pen.

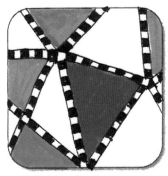

5 Add color to some sections.

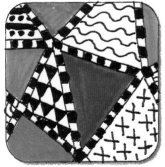

6 Draw patterns in the remaining sections.

Grid Ideas

Circuit Board Grid

Draw closed-line shapes that overlap with themselves, then draw more closed-line shapes on top of the first few.

Geometric Lines Grid

Draw vertical lines, then add wavy horizontal lines and some additional short vertical lines.

Colored pencils by Cindy Shepard

Circles Grid

Draw concentric circles, then add more circles around on top of them.

Markers by Ann Smith

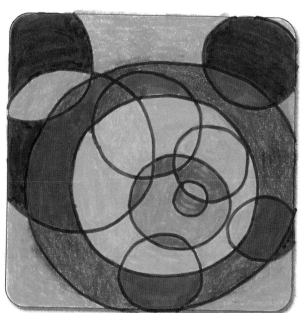

Markers by Sharon Giles

Grid Gallery

Color adds energy and endless variation to designs. The way you color a design can bring an object into the foreground or fade it into the background. Check out these fun examples, and then pattern and color your own grids on page 19!

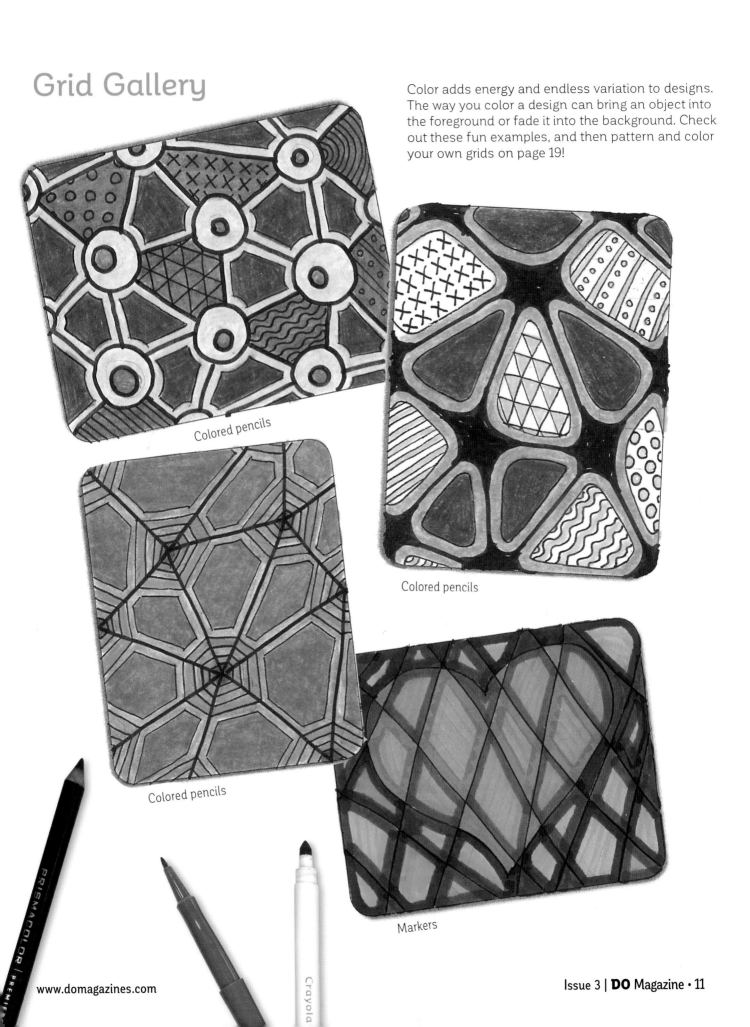

Colored pencils

Colored pencils

Colored pencils

Markers

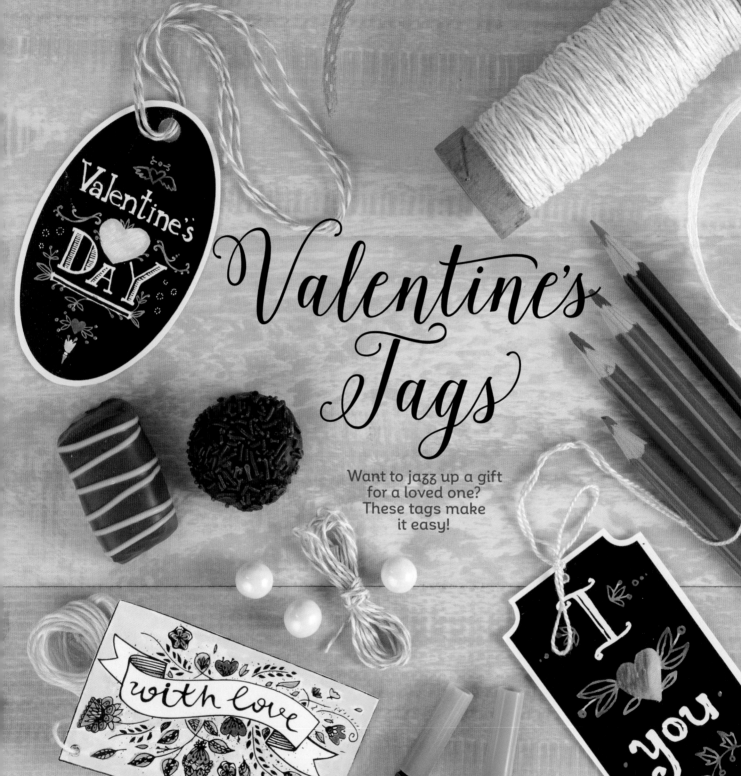

Valentine's Tags

Want to jazz up a gift
for a loved one?
These tags make
it easy!

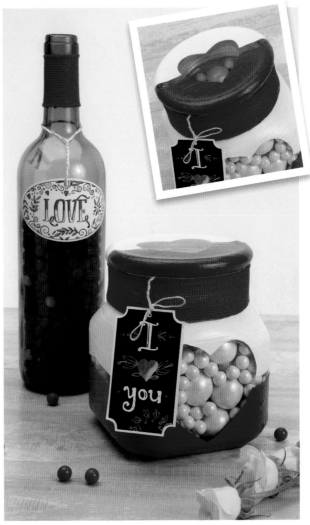

Simply color and cut out the cardstock gift tags on the insert after page 16, then tie them onto your chocolates, candle, flowers, or other Valentine's Day presents for a personal touch that shows how much you care.

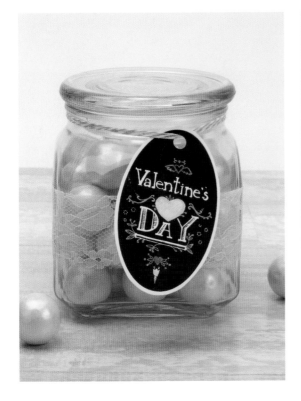

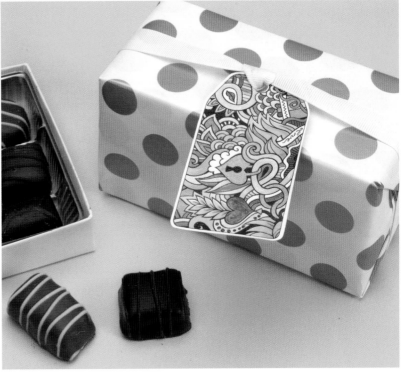

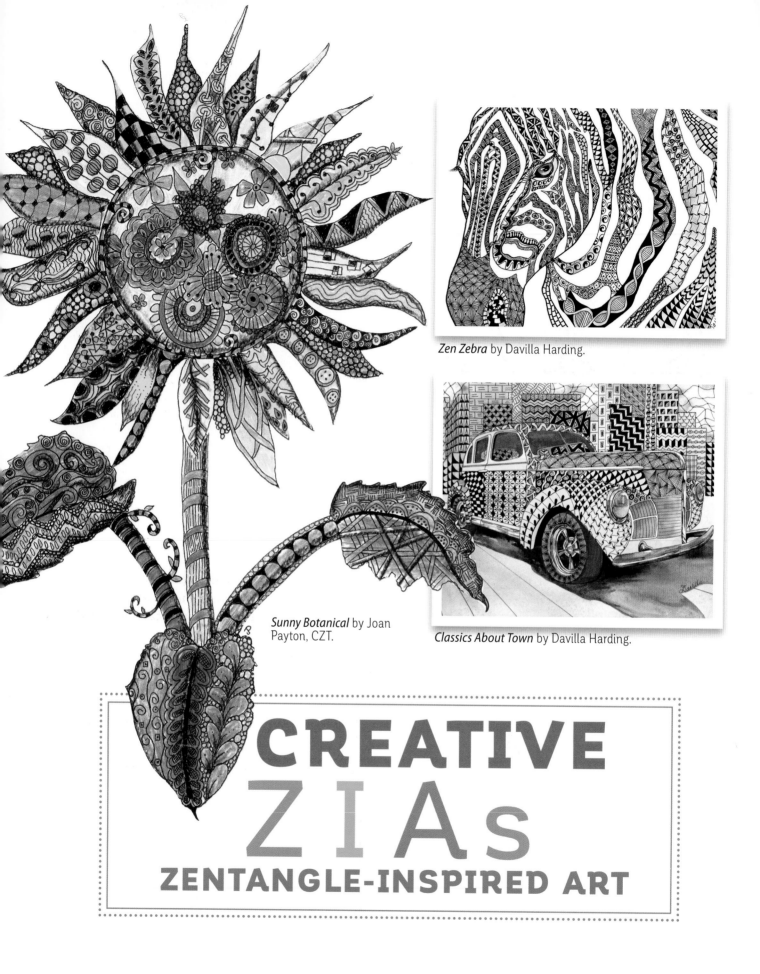

Zen Zebra by Davilla Harding.

Classics About Town by Davilla Harding.

Sunny Botanical by Joan Payton, CZT.

CREATIVE
ZIAs
ZENTANGLE-INSPIRED ART

What is a ZIA?

ZIA stands for Zentangle-Inspired Art, but what does that mean exactly? A traditional Zentangle piece is created in black and white using a pencil and pen. The piece is created following the Zentangle method, a series of steps developed by Rick Roberts and Maria Thomas; it incorporates tangles (simple step-by-step patterns); and the end result is abstract (it has no top or bottom and can be viewed from any direction).

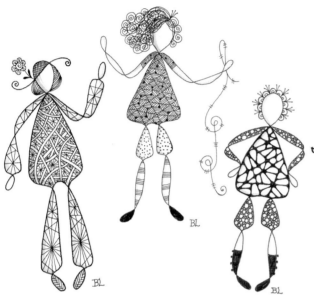

Tanglefolk by Billie Lauder, CZT.

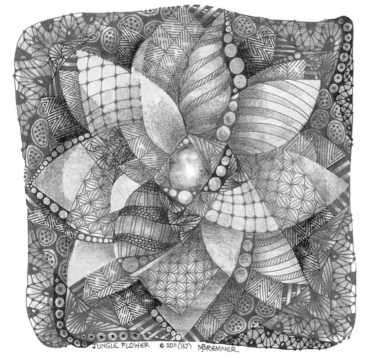

Jungle Flower by Margaret Bremner, CZT.

Rainbow Cat by Marta Drennon, CZT.

Traditional Zentangle Art

- ☑ Black, white, and shades of gray
- ☑ Created following the Zentangle method
- ☑ Abstract (no distinct shape and can be viewed from any direction)

ZIAs incorporate tangles but do not follow any of the other rules of a traditional Zentangle piece. ZIAs often have a distinct shape. For example, you might choose to fill the outline of a heart or a bird with tangles. This is considered a ZIA. Because traditional Zentangle is only in black and white, adding color to a Zentangle piece also makes it a ZIA. ZIA designs are incredibly creative and inspiring. Here are some of our favorites.

Zentangle-Inspired Art

- ☑ Incorporates tangles
- ☑ Has a distinct shape
- ☑ Includes color

Abstract art is still a ZIA if it incorporates color, and black and white art is still a ZIA if it has a distinct shape.

Making Your Own ZIA

Creating ZIAs might seem intimidating, but there are lots of tools you can use to make the process easier.

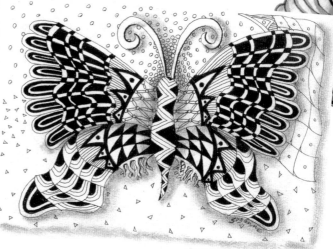

Under the Sea by Kate Lamontagne, CZT.

Creating your own ZIAs is easy, especially if you start with an outline. Divide the outline into sections and draw a tangle in each one.

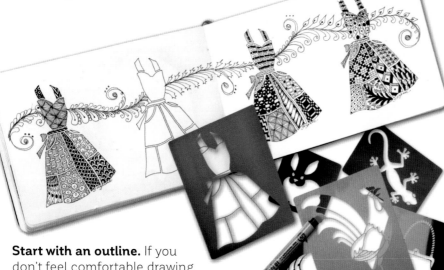

Start with an outline. If you don't feel comfortable drawing a shape to fill with tangles, no problem! You can use stamps, stencils, or even online clipart to get the shape you want. Try repeating the same outline and filling each one in differently. The possibilities are endless.

Try an Ornation Creation template. Artist Ben Kwok started creating his unique templates specifically for the Zentangle community. He divides each design into smaller sections, providing lots of spaces for adding tangles or color. Check out some of Ben's templates on pages 89–92.

See pages 21 to 24 for outlines to tangle!

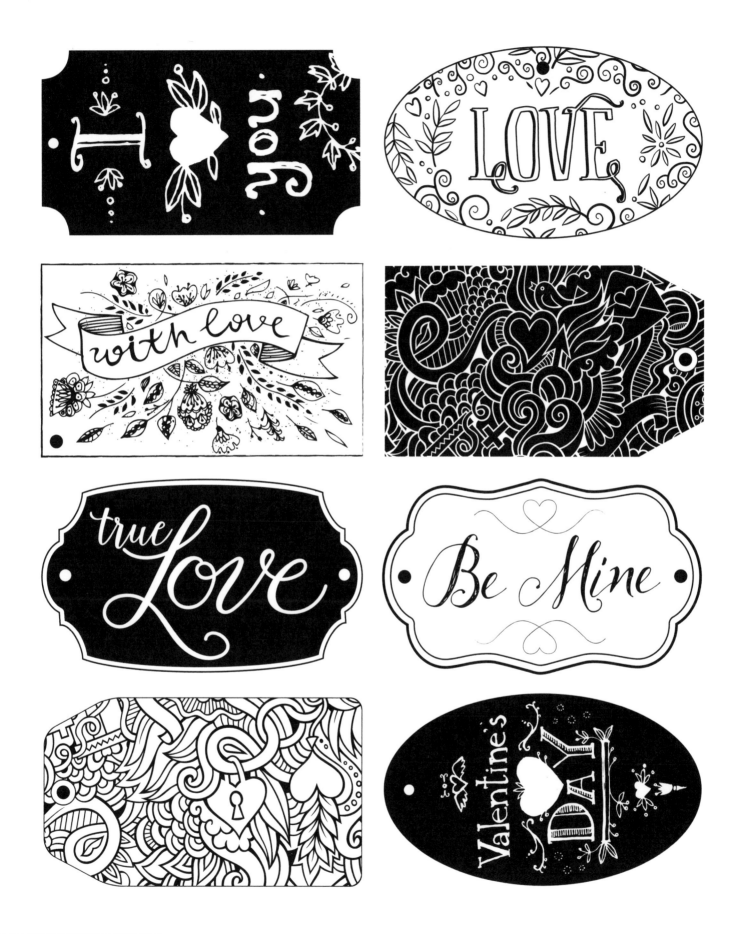

See page 12 for ideas on how to use these gift tags.

Happiness blooms from within.
—Unknown

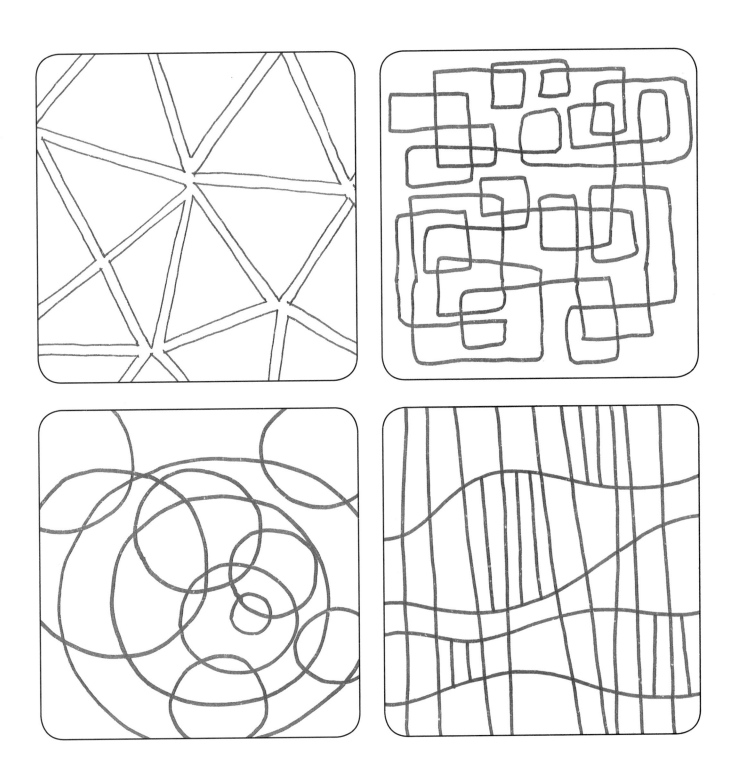

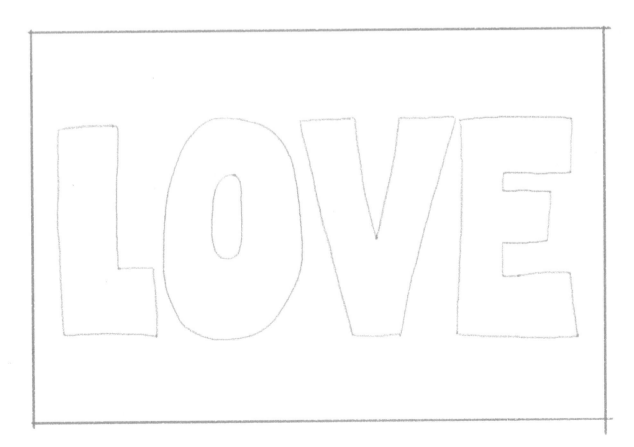

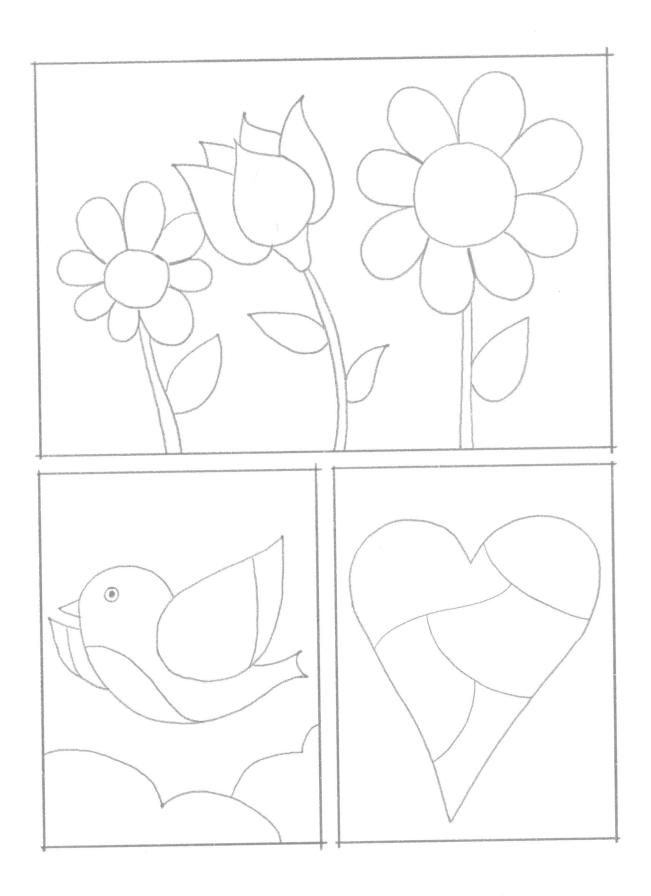

© DO Magazine and Thaneeya McArdle

Life does not have to be perfect
to be wonderful.

—Unknown

Flowers don't tell, they show.

—Unknown

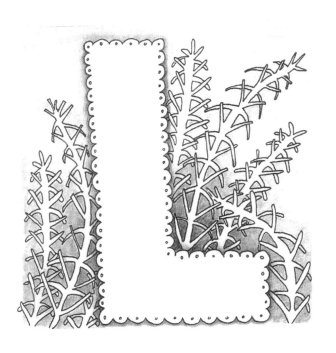

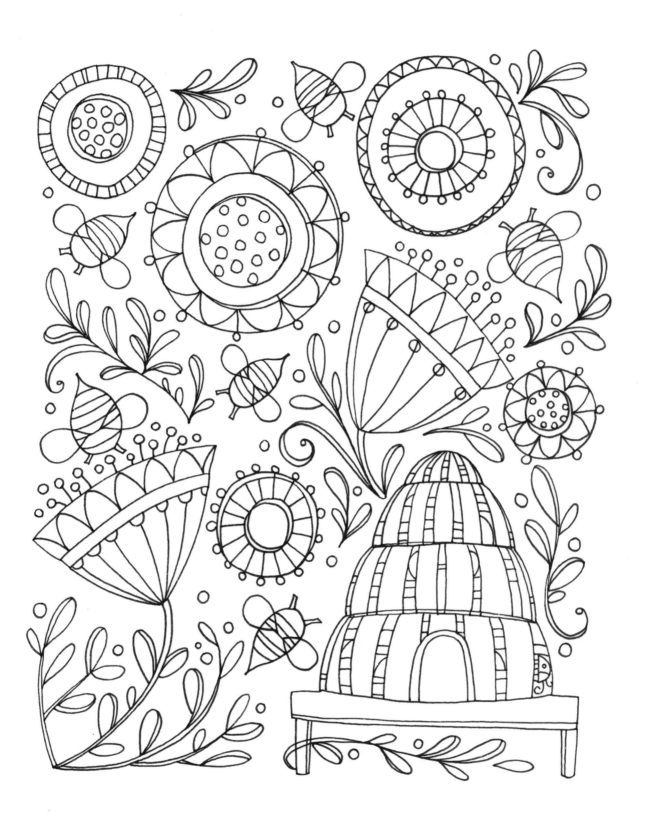

*Ladybugs are just
as sweet as honey*

Decoupage your Colored Art

4 Easy Steps with Mod Podge

We love Mod Podge! Seriously... who doesn't? It's an amazing all-in-one glue, sealer, and finish. It's super easy to use, and, even better, with this single crafting medium you can create loads of adorable projects. Our favorite projects to make with Mod Podge?

Ones that feature your colored art, of course! Check out this foolproof method for decoupaging colored art onto any surface you can imagine, brought to you by Mod Podge expert Amy Anderson, *www.modpodgerocksblog.com.*

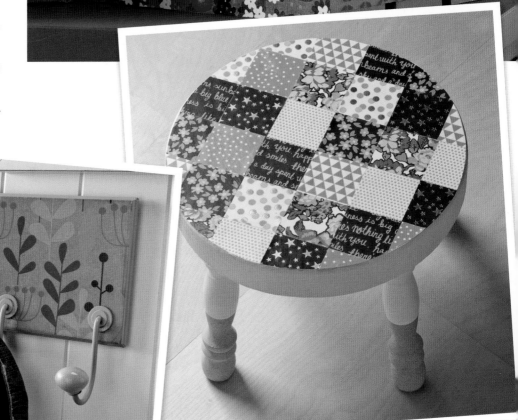

1. Prepare your surface and art. You can decoupage colored art onto almost any surface, including wood, papier mache, terra cotta, tin, cardboard, glass, and canvases. Only some plastics can be used for decoupage—test them first with a paper scrap. If your surface is unfinished, you may wish to apply a basecoat of paint before decoupaging onto it. Trim your colored design to fit your surface.

2. Apply Mod Podge. You have two choices. For one, you can apply a moderate coat of Mod Podge to your surface. It's better to apply too much than too little—using too little will create wrinkles, while you can always wipe away any excess. Or, you can apply a coat of Mod Podge to your art, especially if your art isn't going to fill the surface on which you are placing it.

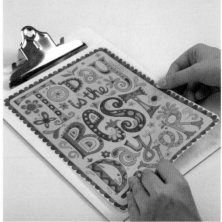

3. Apply your art. Place your colored art carefully on your surface. Smooth away any bubbles or wrinkles, working from the center outward. Allow your project to dry for 15–20 minutes.

Find this Clipboard pattern on page 25

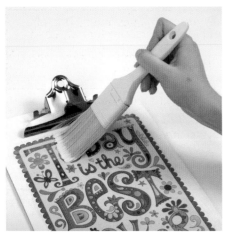

4. Add a topcoat. Once your project is dry, apply a coat of Mod Podge over its entire surface to seal and protect it. Allow everything to dry and repeat. You can apply as many topcoats as you'd like; I recommend at least two. If your project feels tacky when you've finished or you just want some extra durability, finish it with a clear acrylic sealer.

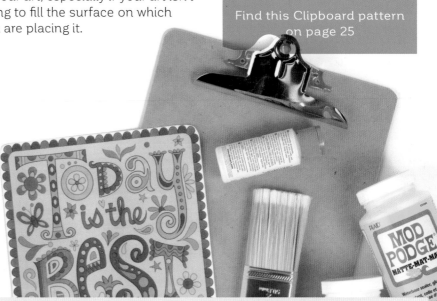

Important!

Mod Podge is water based and might cause smearing or streaking when applied over top of water-based coloring mediums. Check out the comprehensive overview of how different brands of coloring mediums react to Mod Podge at *http://modpodgerocksblog.com/ mod-podge-using-with-ink-pads-pens-pencils-markers-and-more*. As a general rule, you should be able to use Mod Podge successfully over colored pencils, chalk pencils, gel pens, artist pens, ballpoint pens, crayons, alcohol-based markers, and paint pens. But you might experience smearing or streaking if you apply Mod Podge over watercolor pencils or water-based markers. If you are concerned that your colored art might smear, spray both sides with a clear acrylic sealer and allow it to dry before decoupaging.

Tips & Tricks

- Most coloring designs are printed on thick paper and are ready to be decoupaged as is. If you are concerned that your paper is too thin, spray both sides with a clear acrylic sealer and allow it to dry before decoupaging.
- For smoothing out the bubbles and wrinkles, I like to use a brayer (for large projects) and a squeegee (for small projects).
- For an extra-smooth finish, wet a piece of 400-grit sandpaper and sand your project lightly between each Mod Podge topcoat you apply. Polish the final coat of Mod Podge with #0000 steel wool.
- Remember that Mod Podge is a water-based product and is not waterproof. Finish projects that might come in contact with water, like coasters, vases, etc., with a clear acrylic sealer.
- You can speed up the drying time for Mod Podge with a hair dryer; just keep it at least 12" (30cm) from your project and use the cool or warm setting.

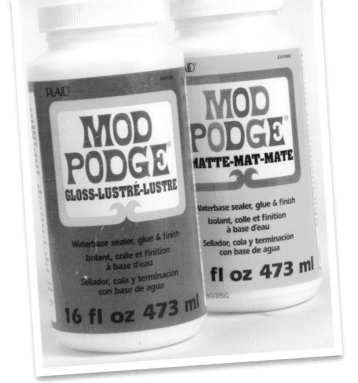

How Do **YOU** Mod Podge?

Mod Podge is available in many different finishes. Here's a quick guide to help you find your Mod Podge style. There are even more styles than listed here, so go shopping!

NAME	FINISH
Matte	Classic Mod Podge with a flat finish. This is your all-around Mod Podge product and can be used for any decoupage project.
Satin	Classic Mod Podge with a soft, non-glossy finish.
Gloss	Classic Mod Podge with a shiny finish.
Ultra Matte Chalk	Mimics the look of chalk-finish paint. Very flat (no shine), soft to the touch, and does not show brushstrokes.
Sparkle	Contains glitter pieces for some sparkle and shine.
Pearl	Creates a shimmery finish that changes colors in the light. Best used over dark or saturated colors as the formula is translucent, but not clear.
Paper (Gloss or Matte)	An archival-quality formula that will protect photos and paper over time.
Antique (Matte)	Has a slightly brown tint. This is perfect for creating an heirloom look.
Brushstroke (Gloss or Matte)	Clear finish with a very textured, dimensional look that creates a hand-painted effect.
Hard Coat (Satin)	Most durable formula. Perfect for projects that will be handled and used frequently.
Outdoor	Most water-resistant formula for projects meant to be outdoors. Note: Although this formula is extremely water resistant, it is not waterproof.

AlphaTangle Wall Art

Monograms, letters, and word art make wonderful home décor pieces that add a unique, personal touch to any room. Feature your initial, family name, or favorite positive word or message—whatever inspires you and puts a smile on your face when you look at it! This design features the LOVE pattern on page 29. For a twist on this project, cut out and frame each letter individually.

Materials

- Markers, colored pencils, and/or gel pens
- Scissors or craft knife
- Picture frame

Project pattern by Sandy Steen Bartholomew, from her new book *AlphaTangle, Expanded Workbook Edition.*

1. **Embellish the pattern.** Find the LOVE pattern on page 29 and tear it out. If desired, add more patterning in or around the letters.

2. **Color the pattern.** Color the design with markers, colored pencils, and/or gel pens.

3. **Frame the design.** You can get creative with your framing by trimming the design to fit a small frame or using unique matting in a large frame. If desired, you could also cut out and frame each letter separately.

4. **Display your frame.** Hang it on the wall, set it on the mantle, or place it on an end table to show off your work!

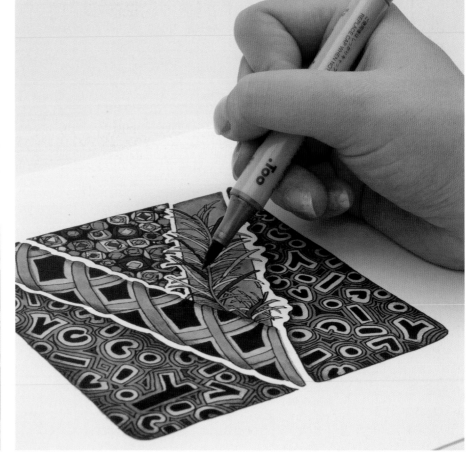

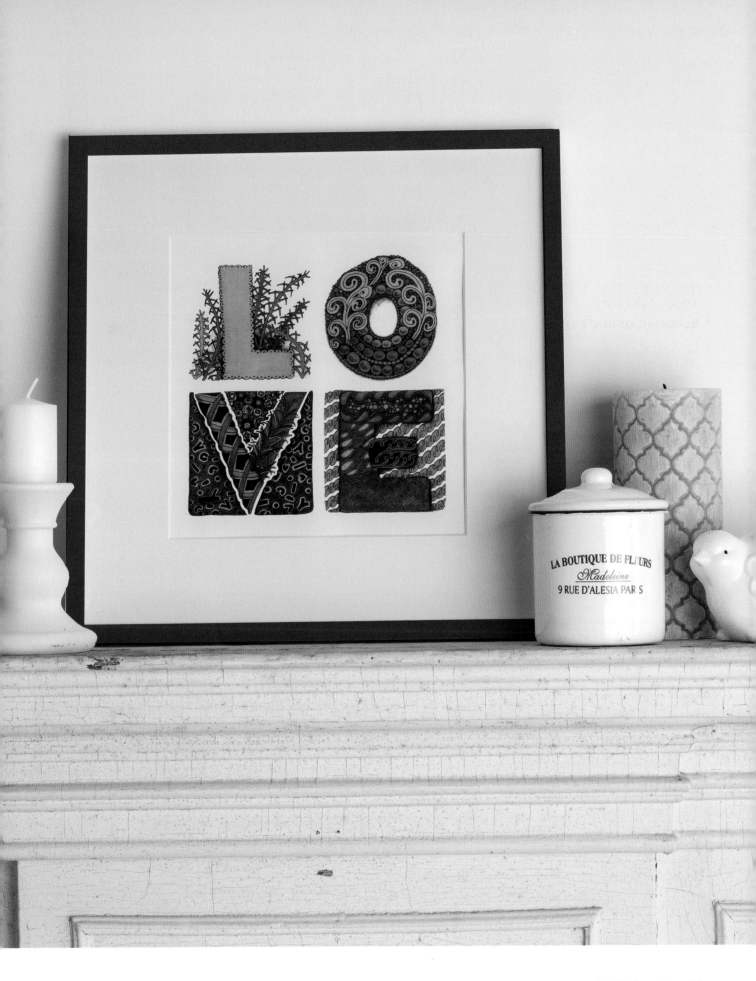

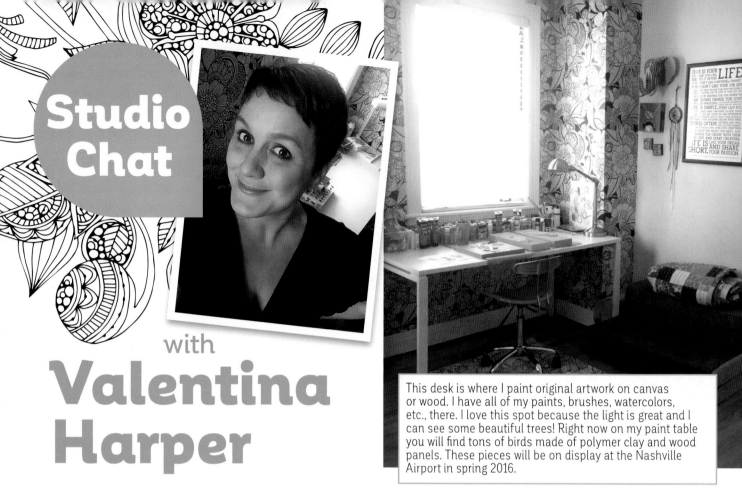

Studio Chat

with
Valentina Harper

This desk is where I paint original artwork on canvas or wood. I have all of my paints, brushes, watercolors, etc., there. I love this spot because the light is great and I can see some beautiful trees! Right now on my paint table you will find tons of birds made of polymer clay and wood panels. These pieces will be on display at the Nashville Airport in spring 2016.

You've probably seen designs by talented artist and author Valentina Harper on iPhone cases, home décor items, and coloring books sold in stores all over the country and didn't even realize it! Valentina's dense, lush style and inspirational lettering have become the favorite of many adult colorists. Her coloring book series Creative Coloring has wowed—and relaxed—countless colorists, and her book *Creative Coloring Inspirations* has sold more than 350,000 copies. We chatted with the 42-year-old native of Venezuela and Nashville transplant and got a tour of her awesome home workspace. Join us!

How did you decide to make art your life instead of your hobby?
I have a degree in graphic design and I always created artwork, but mostly it was for my family and friends. I've always worked as a graphic/web designer as my main job. In 2009, though, I went through a big personal change, and I decided to take that time to reinvent myself. From then on, I decided to be an artist and make artwork for a living. It was not a hard decision, but it was definitely a challenging one.

What inspires your art?
Colors and people are my main inspirations. I'm also inspired by inspiring others. I love to create positive and uplifting art that lifts other people's ideas and spirits.

What is your artistic process?
I just draw the main figures in pencil and start filling them up with ink. I don't have a predetermined pattern or whole idea in mind—I just take my pen and start drawing.

How long does it take to complete a design?
This is the most difficult and constant question I get! I cannot really calculate the time per drawing because I'm usually working in several drawings at the same time. Right now, I have three different canvases on my table!

What are your must-haves when drawing?
I work watching TV shows and/or movies on my computer all day long! I might not pay attention at all to the movie, but I love the background noise.

Are you tidy or messy?
Believe it or not, I love to work in an organized space! Every night before "closing the shop" I try to organize to start the next day with everything in order. I can't work or concentrate if I have a mess around!

Check out some of Valentina's designs to color on pages 49-52!

Some of the new drawings for my next coloring book! I always have two or three Koh-I-Noor Rapidograph technical pens around. I cannot live without those pens. And I have been using them since design school in Venezuela!

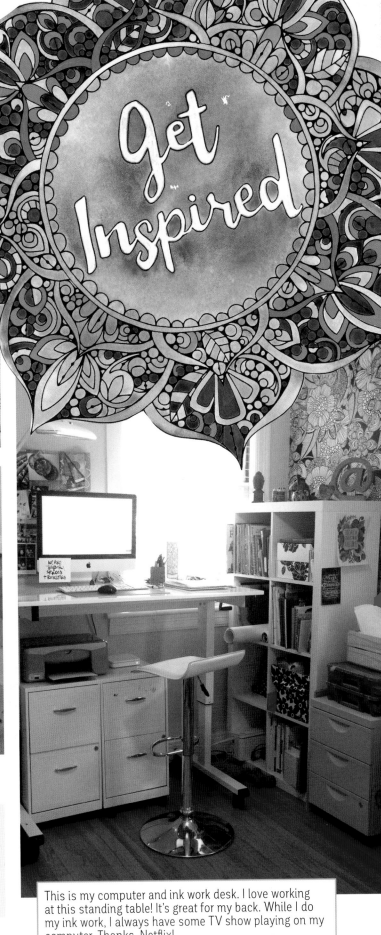

Get Inspired

This is my 3-year-old's co-workspace! My daughter "works" there while I "try" to work.

Check out all of Valentina's books, including her newest, *Creative Coloring Inspirations 2*, the followup to the bestseller. Ordering info is on page 77.

This is my computer and ink work desk. I love working at this standing table! It's great for my back. While I do my ink work, I always have some TV show playing on my computer. Thanks, Netflix!

White Glow Stamped Card

Here's a great way to combine stamping and coloring! Simply use white ink instead of black ink to add a unique twist to your stamping project. It's an easy trick that most people don't think of! This whitewashed technique really allows your designs to "glow," with the color popping off the page. And with a few ways to approach it, this technique will help you make endless interesting cards, gift tags, and more.

Materials

- Stamps (technique works best with stamps with larger empty areas/less detail)
- White inkpad
- Colored pencils, markers, watercolors, or other preferred coloring media
- Paper or cardstock card (best in any neutral color other than white)
- Embellishments as desired

1. **Prep the stamp.** Use the white inkpad to adequately cover the rubber surface of the stamp with ink.

2. **Stamp the design.** Press the stamp to the paper in the desired location, being careful to apply enough pressure to all parts of the stamp. Carefully remove the stamp and allow the image to dry.

3. **Option 1.** Color only in the empty spaces of the stamp, creating an effect with a white outline that pops.

4. **Option 2.** Using light watercolors or by pressing lightly with colored pencils, color the entire stamp, including the white lines, allowing the stamp lines to show through.

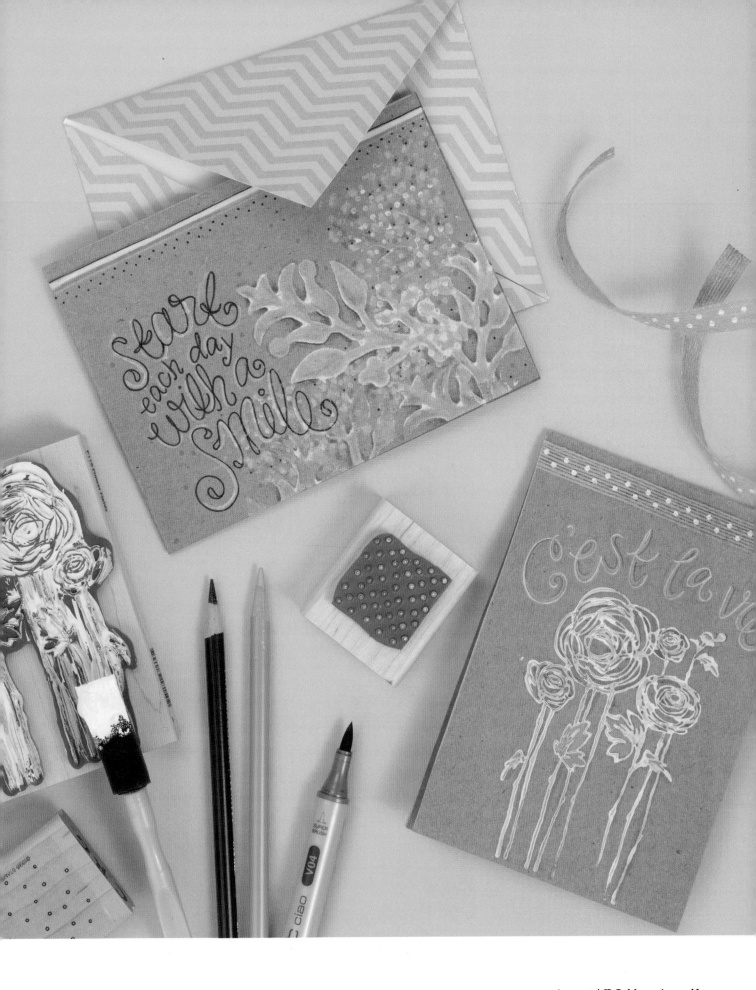

Hello Angel!

Inspiration and Techniques from International Coloring Sensation Angela Van Dam

Get ready to meet the latest coloring talent. Working from her studio in New Zealand, Angela "Angel" Van Dam has been inspiring people all around the globe with her bright colors, intricate patterns, and amazing designs . A graphic designer by trade, Angel wants to be in her studio making art almost all of the time—it's what makes her happy. The fact that her art inspires others makes her doubly happy and motivates her to create so much more. Now, with her new series of books launching in the United States, it's your chance to have a sneak peek into Angel's life and other-worldly art. In this article, you will see some samples of her work and learn some of her best tips for layering, blending, and patterning—and then you can have fun trying out her techniques on the special excerpts on pages 53–58.

Let's say hello to Angel!

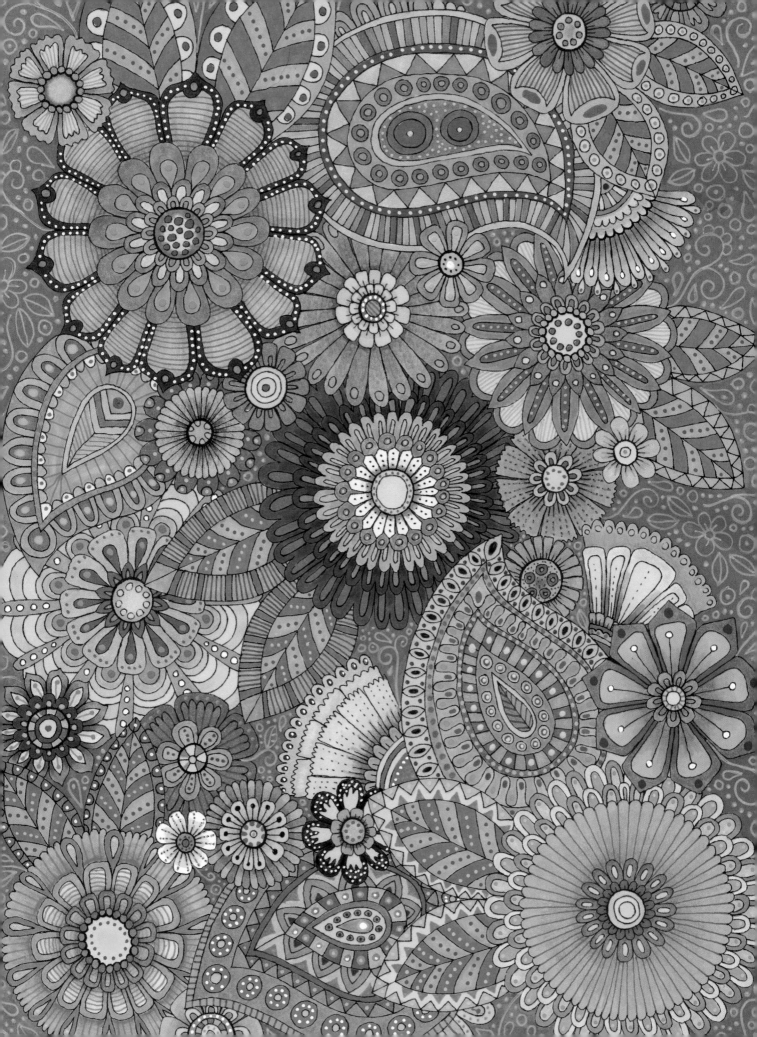

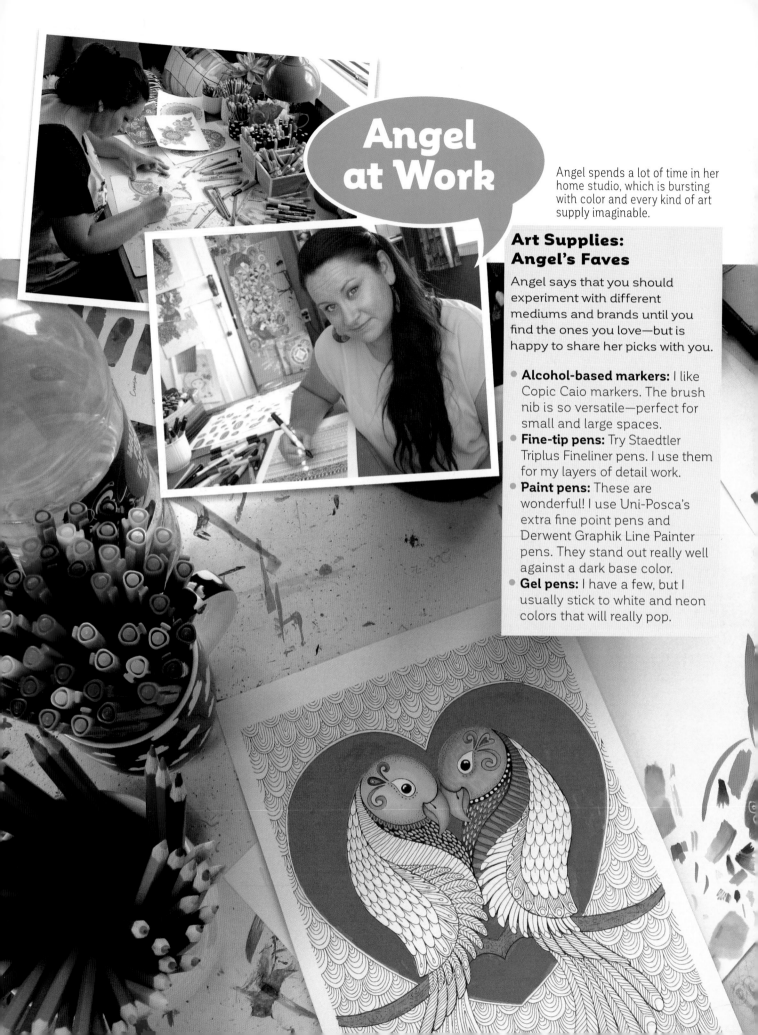

Angel at Work

Angel spends a lot of time in her home studio, which is bursting with color and every kind of art supply imaginable.

Art Supplies: Angel's Faves

Angel says that you should experiment with different mediums and brands until you find the ones you love—but is happy to share her picks with you.

- **Alcohol-based markers:** I like Copic Caio markers. The brush nib is so versatile—perfect for small and large spaces.
- **Fine-tip pens:** Try Staedtler Triplus Fineliner pens. I use them for my layers of detail work.
- **Paint pens:** These are wonderful! I use Uni-Posca's extra fine point pens and Derwent Graphik Line Painter pens. They stand out really well against a dark base color.
- **Gel pens:** I have a few, but I usually stick to white and neon colors that will really pop.

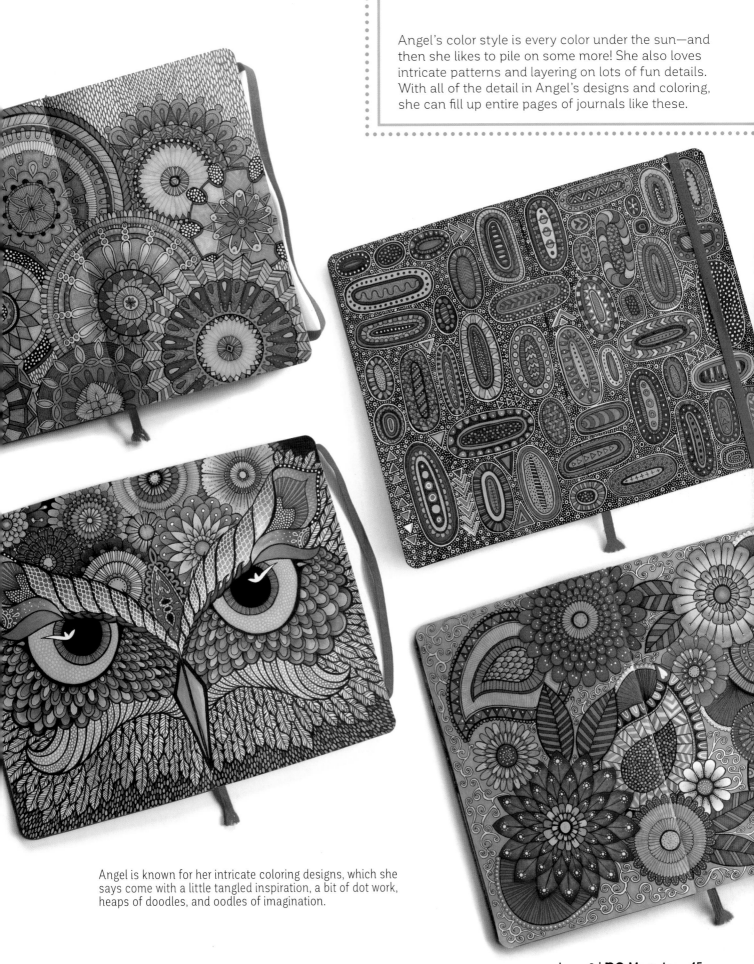

Angel's color style is every color under the sun—and then she likes to pile on some more! She also loves intricate patterns and layering on lots of fun details. With all of the detail in Angel's designs and coloring, she can fill up entire pages of journals like these.

Angel is known for her intricate coloring designs, which she says come with a little tangled inspiration, a bit of dot work, heaps of doodles, and oodles of imagination.

Learn more about Angel, her art, techniques, and positive inspirations on her website, *www.helloangelcreative.com*, and at *www.domagazines.com*.

Look for Angel's upcoming titles!

Look for Angel's coloring books in February 2016. Let *Mindfulness* fill you with positive inspiration, check out *Big Beautiful Blossoms* for a garden of floral designs, and embrace your wild side with the unique images in *Animals*.

BIG BEAUTIFUL BLOSSOMS
· ADULT COLORING COLLECTION ·

ANIMALS
· ADULT COLORING COLLECTION ·

MINDFULNESS
· ADULT COLORING COLLECTION ·

Layering and Blending with Hello Angel

I love layering and blending colors. It's a great way to create shading and give your finished piece lots of depth and dimension. The trick is to work from the lightest color to the darkest and then go over everything again with the lightest shade to keep the color smooth and bring all the layers together.

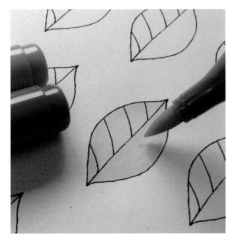

1 Apply a base layer with the lightest color.

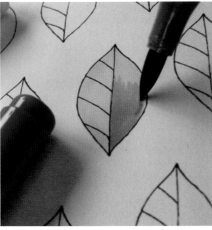

2 Add the middle color, using it to create shading.

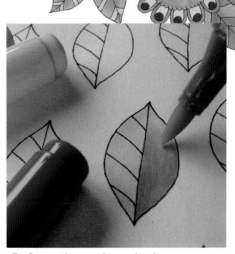

3 Smooth out the color by going over everything with the lightest color.

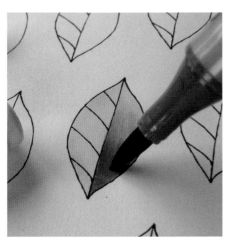

4 Add the darkest color, giving your shading even more depth. Use the middle color to go over the same area you colored in Step 2.

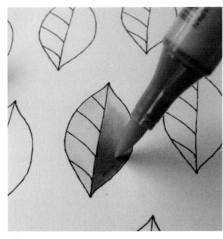

5 Go over everything with the lightest color as you did in Step 3.

Patterning and Details

Layering and blending will give your coloring depth and dimension. Adding patterning and details will really bring it to life. If you're not convinced, try adding a few details to one of your colored pieces with a white gel pen—that baby will make magic happen! Have fun adding all of the dots, doodles, and swirls you can imagine.

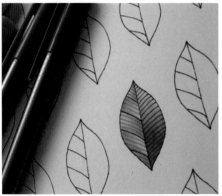

1 Once you've finished your coloring, blending, and layering, go back and add simple patterning like lines or dots. You can add your patterns in black or color. For this leaf, I used two different shades of green pen.

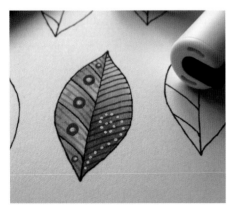

2 Now it's time to add some fun details using paint pens or gel pens. Here, I used white, yellow, and more green.

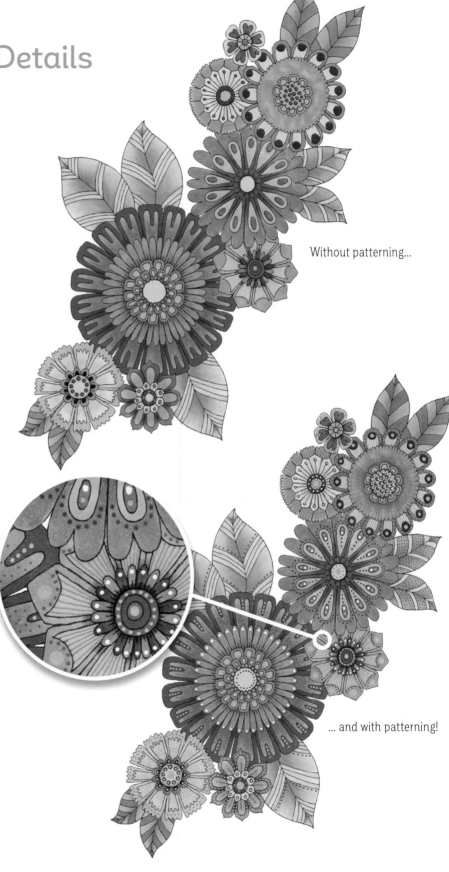

Without patterning...

... and with patterning!

Check out these two designs. The one on the top has depth and dimension created by layering and blending the colors. The one on the bottom really pops with lots of patterning and little details.

Don't stop trying just because you've hit a wall. Progress is progress no matter how small.

—Unknown

Be Brave

Have the courage to follow your heart and intuition. They somehow already know what you truly want to become.

—Steve Jobs

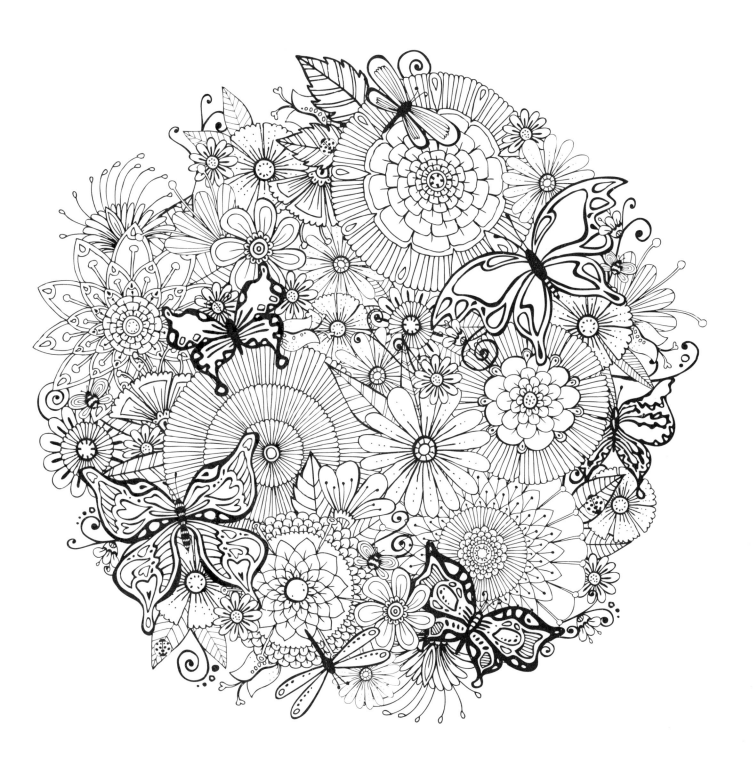

Go as far as you can see;
when you get there, you'll be
able to see farther.

—Unknown

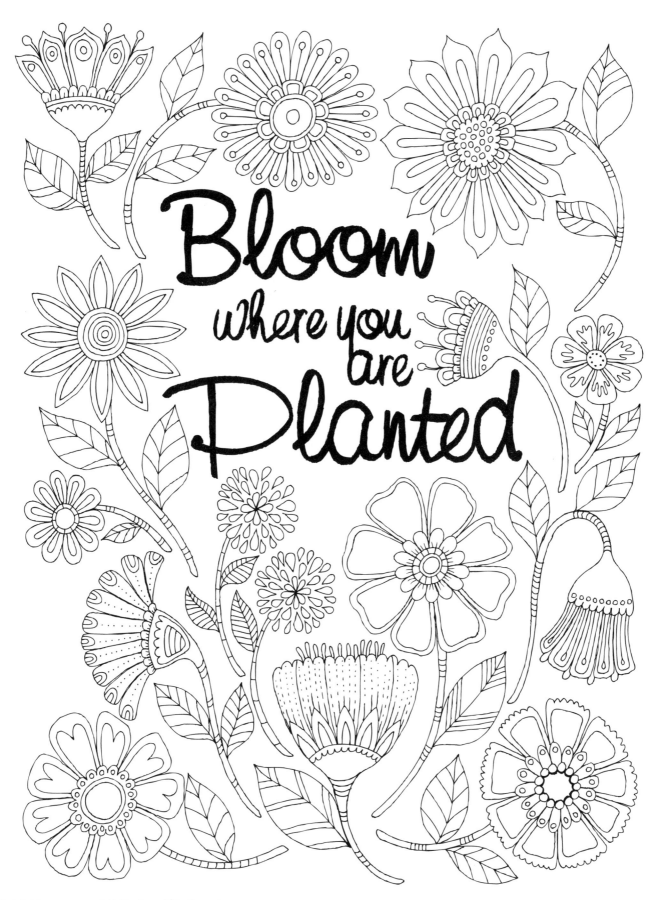

Bloom where you are Planted

You are built, not to shrink down to less, but to blossom into more.

—Oprah Winfrey

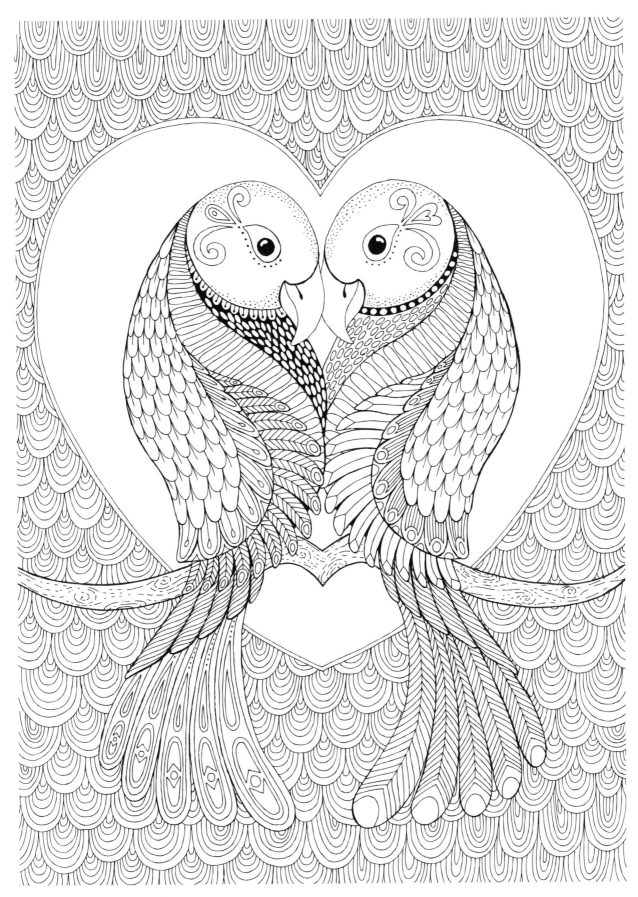

When you love and laugh
abundantly you live a
beautiful life.

—Unknown

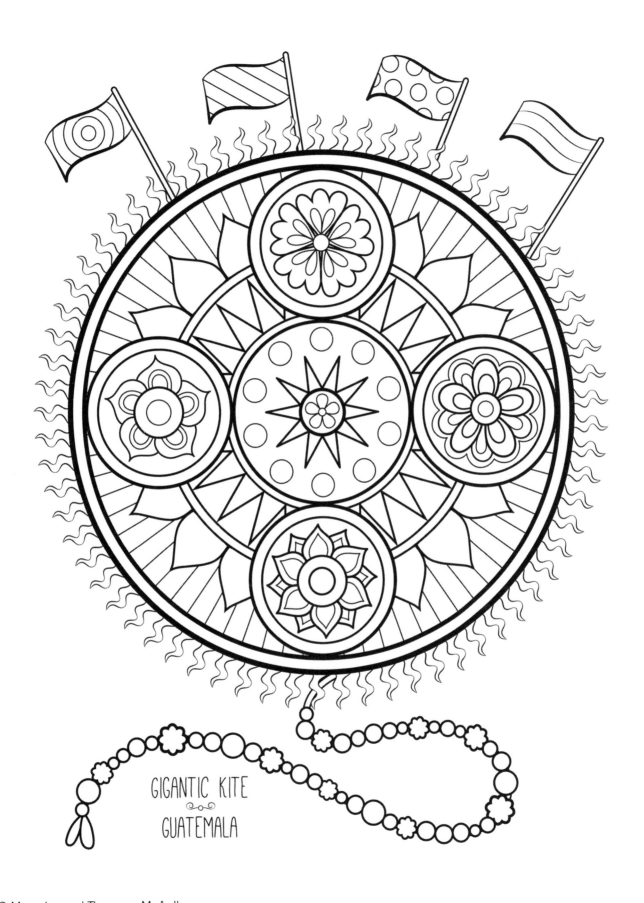

GIGANTIC KITE
GUATEMALA

True courage is like a kite; a contrary wind raises it higher.

—Jean Petit-Senn

The road to my heart is paved
with paw prints.

—Unknown

A friend is what the heart
needs all the time.

—Henry Van Dyke

2016 Coloring Calendar

FREE with your paid 2-year subscription **The 2016 Coloring Calendar** (a $12.99 value)

color
tangle
craft
doodle

DON'T MISS A SINGLE ISSUE!
Subscribe Today and Save 30%!

Subscribe Today & SAVE 30%

FREE with your paid 2-year subscription - 2016 Coloring Calendar a $12.99 value!

Annual Cover Price	Your Price
~~$39.96~~	**$27.99**

Canadian subscribers add $5.00, all other countries, add $10.00 (U.S. funds only). *DO Magazine* is published 4 times per year. Please allow 4-6 weeks for delivery of first issue.

✓ **YES!**

☐ **Send me one year for only $27.99** (a $39.96 value)

☐ **Send me two years for only $55.98** (a $92.91 value) I get the 2016 coloring calendar free (a $12.99 value)

Name: _____

Address: _____

City: _____

State/Prov.: _____

Country: _____ Zip: _____

E-mail: _____

☐ Payment enclosed ☐ Bill me later

☐ Start my subscription with Premiere Issue #1

☐ Start my subscription with this Issue #3

☐ Start my subscription with the next Issue #4 U161DSA

Subscribe Today & SAVE 30%

FREE with your paid 2-year subscription - 2016 Coloring Calendar a $12.99 value!

Annual Cover Price	Your Price
~~$39.96~~	**$27.99**

Canadian subscribers add $5.00, all other countries, add $10.00 (U.S. funds only). *DO Magazine* is published 4 times per year. Please allow 4-6 weeks for delivery of first issue.

✓ **YES!**

☐ **Send me one year for only $27.99** (a $39.96 value)

☐ **Send me two years for only $55.98** (a $92.91 value) I get the 2016 coloring calendar free (a $12.99 value)

Name: _____

Address: _____

City: _____

State/Prov.: _____

Country: _____ Zip: _____

E-mail: _____

☐ Payment enclosed ☐ Bill me later

☐ Start my subscription with Premiere Issue #1

☐ Start my subscription with this Issue #3

☐ Start my subscription with the next Issue #4 U161DSA

DON'T MISS A SINGLE ISSUE!
Subscribe Today and Save 30%!

color

tangle

craft

doodle

We're Loving It!

With the holiday season behind us and a lush spring ahead, why not treat yourself to one of the coolest new products out there? Here's what's we're excited about this season!

Carole Giagnocavo, Publisher: I have always used lightboxes in my creative work, but the traditional models can be big, bulky, and too high to work on comfortably. This sleek model from Huion is lightweight with a low profile. You can adjust the light and take it anywhere because it has a wireless mode. This is a great tool for tracing patterns and templates. Huion LED Light Pad ($79.99, www.huiontablet.com)

Colleen Dorsey, Editor: Spring means longer days and more sunshine! That's why I am looking forward to taking my crafting outside with the Lumi Photo Printing Kit. This product makes it easy to harness the sun's energy to transfer your own digital photos to fabric. It's a great way to make your own patterns and restyle t-shirts, totes, and more. Lumi Photo Printing Kit ($34.95, www.inkodye.com)

Kati Erney, Editorial Assistant: Metallics are definitely in for spring! From fashion to home décor, I am seeing rose gold everywhere. That's why I am loving DecoArt's line of Metallic Lustre waxes. They are so easy to work with and great for putting a little shine on just about anything. Rub it on and buff for a brilliant shine. DecoArt Metallic Lustre in Rose Gold (approximately $7, check your local craft store, www.decoart.com).

Peg Couch, Associate Publisher: I am loving these gorgeous patterned paint rollers from The Painted House. This roller actually has a pattern embossed onto it, making it easy to apply a design to any surface. It's a wonderful alternative to wallpaper and also works great with fabric. It pairs well with chalk paint, too, for upcycling furniture. A bit of a specialty purchase, but really worth it! Tussock Patterned Paint Roller by The Painted House ($31.16, www.etsy.com/shop/patternedpaintroller)

Llara Pazdan, Designer: I'm a little obsessed with the Wink of Luna Metallic Brushes at the moment! If you want fine metallic lines, a gel pen is great, but for larger strokes of metallic shine, you can't beat this product. It applies a clear shimmer with no mess. It comes in a variety of colors. And, seriously—who does not want more classy metallic accents in their life? ZIG Wink of Luna Metallic Brush ($8.88, www.winkofstella.com)

COLORFUL INSPIRATION:
AN ADVENTURE IN GUATEMALA

A kaleidoscope of local color becomes a memorable creative muse

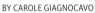

BY CAROLE GIAGNOCAVO

In November, I took a two-week trip with my daughter, Hannah, to her birth country of Guatemala. We spent time helping out at a mountain medical clinic, as well as sharing crafts and creativity with the locals, and we explored the gorgeous scenery of the country.

Wherever we went, vibrant colors surrounded us. The market stands seemed to bring all of the colors together, from the natural colors of the fresh produce to the bright primary colors of plastic ware. The standouts, though, were the beautiful handmade crafts: fabric, paintings, woodcarvings, beadwork, and more. We were struck by how big a role color played in the designs, no matter what the medium was.

This magazine is all about color and design, not about making "perfect" pieces of art—we want readers to use their own artistic styles. I'm reading a book right now about breaking free of perfectionism, and our trip to Guatemala really helped drive that lesson home for me. We saw truly exuberant work done by people who don't have much. As crafters and aspiring artists, we tell ourselves that we'll get "good" or "great" with the right tools, the right studio, the right academic degree—but the people of Guatemala are great without those things. And the truth is, you can be, too.

I brought home a lot of lovely memories, so please let me share a few snapshots from my colorful journey with you—I hope it inspires you!

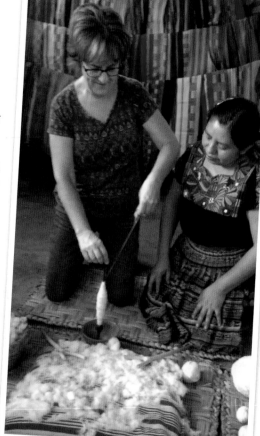

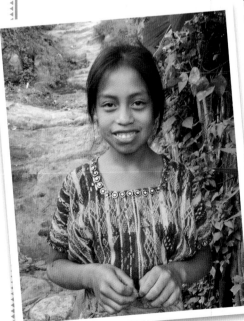

Mayan girls begin learning the craft of weaving at a young age. This 12-year-old girl wove the blouse she is wearing. She was very proud of her design, which was unlike others in her village.

Mayan woman in Guatemala spin, dye, and weave their own thread into intricate patterns for their beautiful clothing. I was given a chance to try my hand at spinning thread, and wasn't a quick learner in this particular case! It takes about two weeks to spin a ball of thread the size of a cantaloupe.

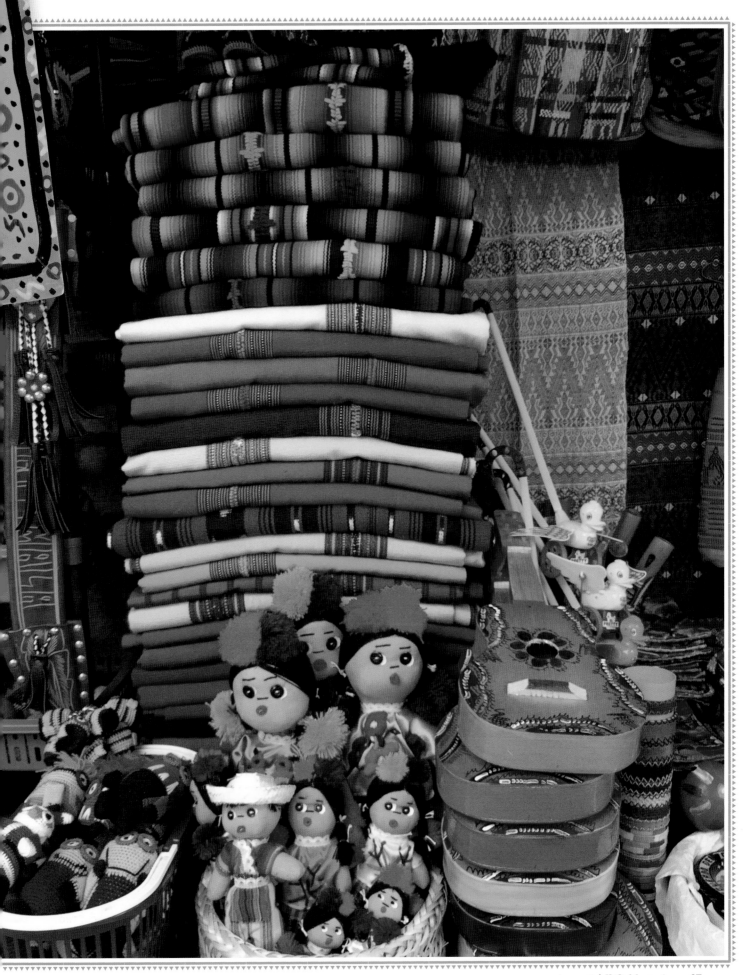

COLOR

Some of the beautiful kites being sold for the Day of the Dead celebration.

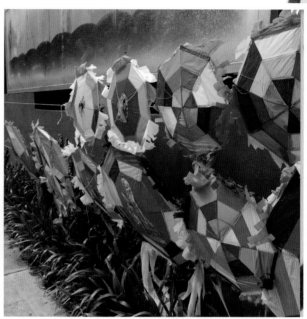

Sometimes the thread used for weaving is hand-dyed, though these particular spools were not. The dyes are natural and come from a variety of plants, such as rosemary leaves, oak bark, guava leaves, coconut shell, and annatto seeds.

Hands of Hope

We met a lot of wonderful people while helping out in my brother-in-law and sister-in-law Greg and Anita Giagnocavo's medical clinic in a mountain village in Guatemala. We also set up a craft table each day we were in the clinic, working with coloring books and making the Christmas ball from issue #2 of *DO Magazine*. For more information, check out the clinic's website (www.hands-of-hope.com) and this video introduction to the clinic: www.vimeo.com/147492594.

Use these colors in your art for a Guatemalan feel! And see page 59 for a Guatemalan kite to color.

CRAFTSMANSHIP

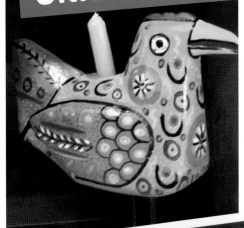

These whimsical, hand-carved wooden animals are a delightful example of Guatemalan folk art.

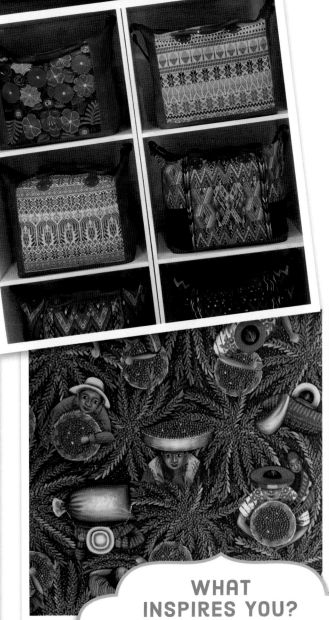

Above: This woman is using a backstrap loom, which is very portable. The back rod is tied to a tree or post while weaving, and the other end has a strap that encircles the waist. The weaver can move backward or forward to produce the necessary tension.

Right; Theses beautiful bags combine traditionally woven fabric with leather to give them a more modern look that appeals to tourists.

Below: "Ant's eye view" (left) and "bird's eye view" (right) paintings are traditional artistic styles that are commonly used.

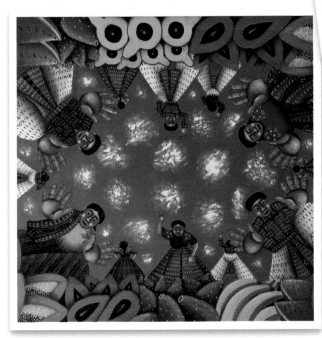

WHAT INSPIRES YOU?

Send us snapshots of what you see that inspires you! We might just feature you in an upcoming issue. (Contact info on page 3.)

Chalk-Style Hall Hanger

This handy hanger is pretty and purposeful! Put it in your entryway to help keep track of your keys, scarves, bags, and jackets. It's super easy to put together using a basic decoupage technique and a painted wood blank from the craft store. This project features a chalkboard coloring design, a new twist on coloring!

Materials

- Markers, colored pencils, and/or gel pens
- Unfinished wood wall rack with hooks
- Black acrylic paint
- Decoupage medium
- Paintbrush
- Picture hanging hardware

Project pattern by Deb Strain

1 **Color the pattern.** Find the pattern on page 81 and tear it out. Color the design with markers, colored pencils, and/or gel pens.

2 **Paint.** Apply two coats of black acrylic paint to the wood rack, allowing the paint to dry thoroughly between coats.

3 **Apply the design.** Apply a thin coat of decoupage medium to the back of your colored design. Be sure to coat the entire design. Position the design over the wood and, working from the center outward, gently smooth the paper onto the wood, flattening any bubbles that may appear. Allow the paper to dry. Next, apply a thin coat of decoupage medium to the entire surface of the wood. Be sure to cover not only your design but the entire painted surface. Allow everything to dry before applying one more coat of decoupage medium all over.

4 **Hang up the rack.** Attach your picture-hanging hardware to the rack according to the package instructions and mount it on your wall.

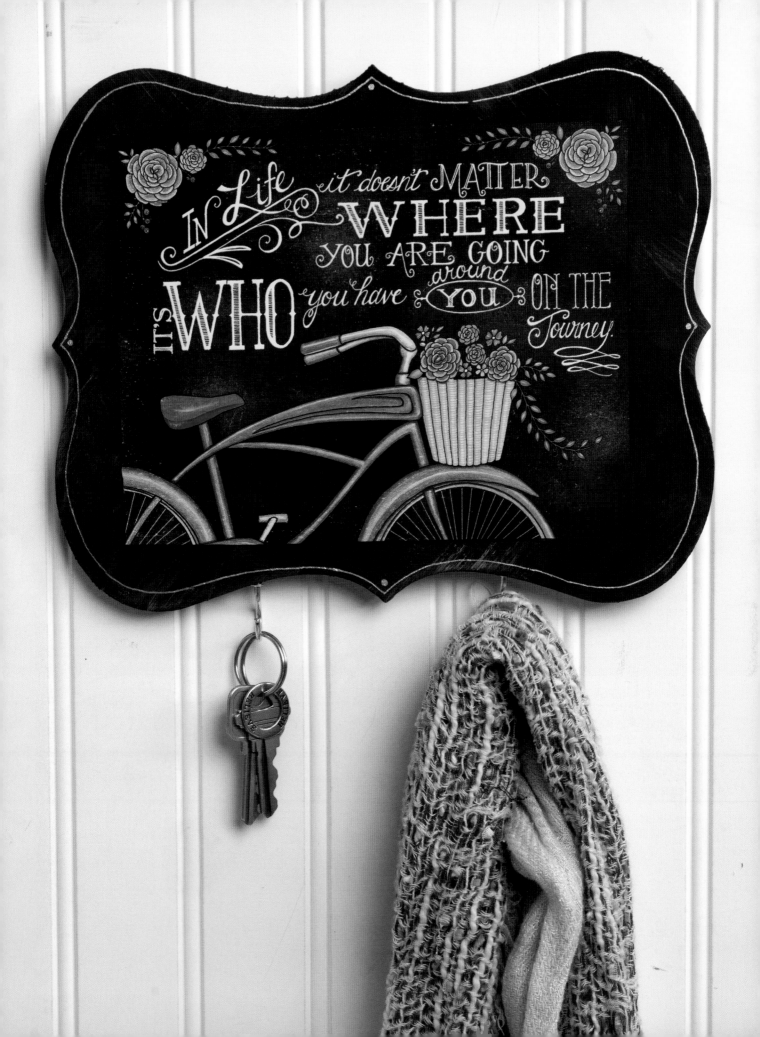

LEARN TO
PATTERN

BY KATI ERNEY

If you're relatively new to the world of coloring and doodling, or don't consider yourself much of an artist, using hand-drawn patterns to emphasize detail in your coloring pages may seem intimidating to you. But we are here to assure you that this artistic technique is nothing to be afraid of—and that it's actually quite simple.

In this lesson on patterning, we will show you how easy and relaxing it can be to make a beautiful piece of art (or add that extra special something to a work you've already created) by incorporating little lines, dots, curlicues, and other hand-drawn embellishments into the empty spaces of a coloring page.

When it comes to patterning, whatever you can imagine, you can create; and here you will find that even the smallest elements can turn any art project into a masterpiece.

This lesson is an excerpt from *New Guide to Coloring*, available now. With all of the amazing coloring books available today, why not read up on great ideas for using color, tips for how to get started, and the kinds of media you can use to color? This book presents a host of lessons and ideas on everything you need to know to make beautiful art from coloring pages. You can find it online at www.d-originals.com.

Step-By-Step Learning

The Basics

All patterns, no matter how complicated, are born from the same basic elements. These elements include lines, circles, dots, curlicues, triangles, and all other geometric shapes. Variations of these basic elements are what allow diverse patterns to be created. Here are some examples of the basics:

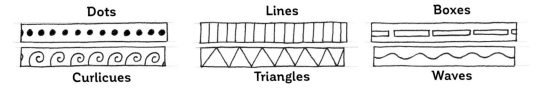

The Next Step

The next step when creating patterns is to combine the basic elements. The use of a few (or many) different basic shapes is what ultimately makes a pattern a pattern. Start by choosing two of the basic elements illustrated above and addin them together to create a new pattern.

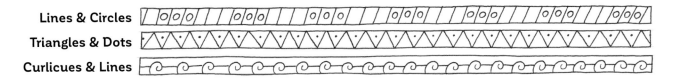

Take It One Step Further

After you've gotten the hang of combining two different basic elements to create a new pattern, take it one step further by combining multiple basic elements. The more basic elements you add to your design, the more complex and detailed your patterning will become.

Lines, triangles, and dots make a funky tribal pattern.

Use Your Imagination

First, you mastered the art of drawing basic geometric shapes and lines; then, you used what you learned to create lines of increasingly complex patterns. Now it's time to use your greatest asset: your imagination. Take the basic elements and morph them into completely new patterning designs. Try cutting your circles in half to create a scallop pattern, or use the same basic elements in different sizes. This step is where you can do whatever you want!

Find new basic shapes!

Get creative!

✳Remember:

Patterning is the repetition, combination, and layering of the same basic elements. Depending on how much space you fill and how many different shapes you incorporate, patterns can be as simple or as complex as you want. The sky is the limit!

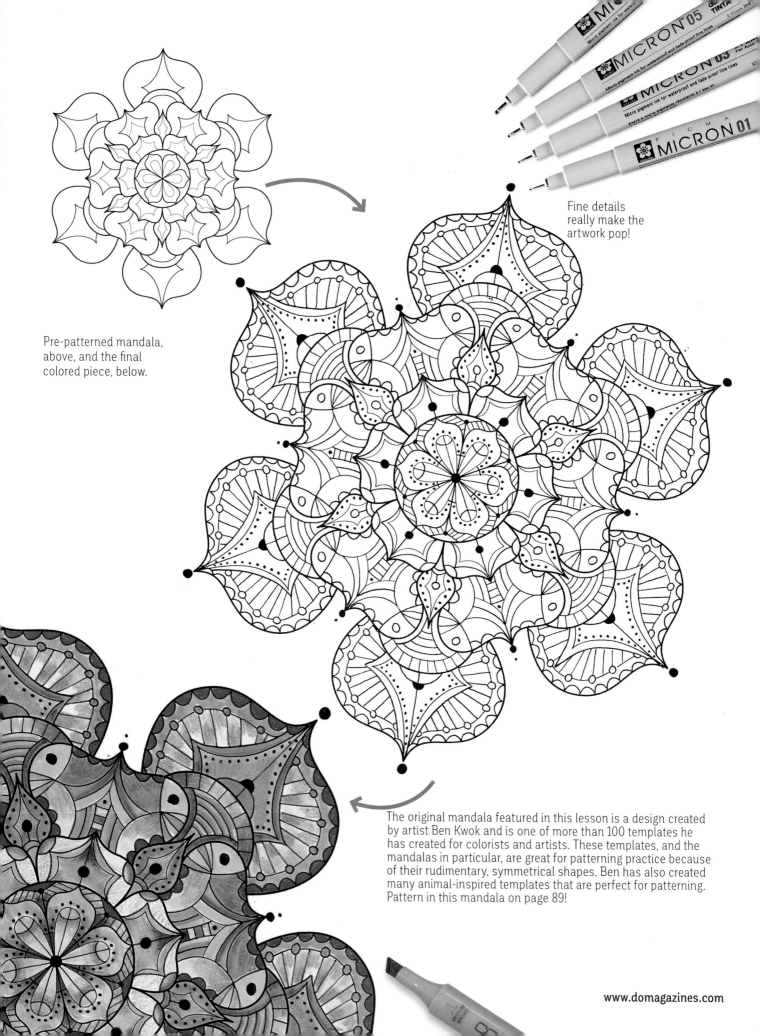

Fine details really make the artwork pop!

Pre-patterned mandala, above, and the final colored piece, below.

The original mandala featured in this lesson is a design created by artist Ben Kwok and is one of more than 100 templates he has created for colorists and artists. These templates, and the mandalas in particular, are great for patterning practice because of their rudimentary, symmetrical shapes. Ben has also created many animal-inspired templates that are perfect for patterning. Pattern in this mandala on page 89!

now you try!

Practice drawing basic elements

Practice combining elements

Practice the funky tribal design here

Create three of your own unique patterns here

Fill in these designs with your patterns

The Zentangle method of patterning is the art of using pre-made patterning designs, or "tangles," to create or embellish an image. There are hundreds of named tangles in the Zentangle universe (such as Flux, Yincut, and Crescent Moon), and these popular patterns can aid and inspire the creation of your own unique designs.

COLOR YOUR OWN STICKERS
Just Color, Peel, and Stick

Personalize your world with an artistic statement that is uniquely yours! Create one-of-a-kind stickers to add style and pizzazz to crafts, home décor, greeting cards, journals, scrapbooks, and more. Each of these unique books offers dozens of whimsical, colorable stickers in an array of sizes, shapes, and styles. Printed on high-quality artist paper, the customizable illustrations are perfect for decorating with colored pencils, gel pens, brush markers, or your favorite craft medium.

Color your own stickers!
- Dozens of pre-cut, self-adhesive stickers
- Coloring tips and inspirational examples
- Use with markers, gel pens, watercolors, crayons, or colored pencils
- Peel and apply to any smooth, dry surface
- Perfect for crafts, scrapbooks, gifts, home décor, and more

Color Your Own Stickers Inspirations
$9.99 • Code: DO5591

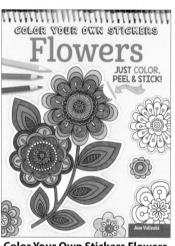

Color Your Own Stickers Flowers
$9.99 • Code: DO5584

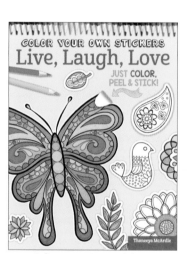

Color Your Own Stickers Live, Laugh, Love
$9.99 • Code: DO5586

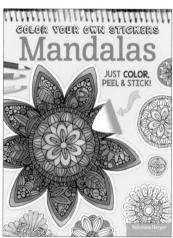

Color Your Own Stickers Mandalas
$9.99 • Code: DO5585

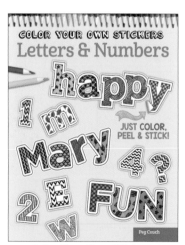

Color Your Own Stickers Letters & Numbers
$9.99 • Code: DO5587

Color Your Own Stickers Frames & Borders
$9.99 • Code: DO5589

Color Your Own Stickers Nature
$9.99 • Code: DO5590

Color Your Own Stickers Party
$9.99 • Code: DO5588

ORDER TODAY! 800-457-9112 • www.D-Originals.com

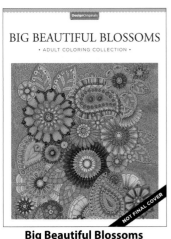
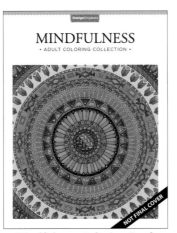
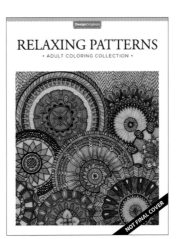
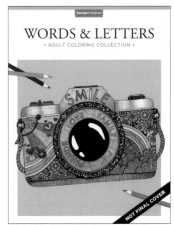

COLORING IS CHEAPER THAN THERAPY!

COLOR STUDIO
COLORING BOOK SERIES

Decorative pattern designer Debra Valencia inspires a world of artistic fulfillment in this new coloring book series. Both aspiring artists and amateur DIY crafters will discover a wealth of original, professional designs. As an added bonus, many beautiful full-color examples are included to show what the designs will look like when different color combinations are used. Perfect for enhancing with markers, gel pens, watercolors, or colored pencils, these art activities are designed for hours of creative experimentation.

- Coloring books with fashion flair
- Sophisticated, contemporary fashion motifs
- Artistic drawings with modern, stylized line work
- Packed with full-color examples
- High-quality, extra-thick paper and perforated pages

Debra Valencia

A World of Coloring Inspiration

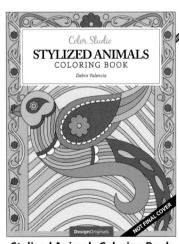

Stylized Animals Coloring Book
$9.99 • Code: DO5697

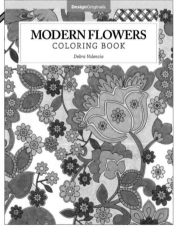

Modern Flowers Coloring Book
$9.99 • Code: DO5535

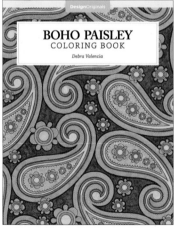

Boho Paisley Coloring Book
$9.99 • Code: DO5536

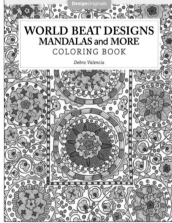

World Beat Designs Mandalas and More Coloring Book
$9.99 • Code: DO5537

NEW BOOKS FOR CREATIVE DOODLING

FLORABUNDA BOOK SERIES

Relax your mind and let your creativity flow with the enchanting FloraBunda drawing method, new from visionary artist Suzanne McNeill. Adding super simple FloraBunda shapes of flowers, leaves, vines, critters, and monograms makes drawing fun! Mix and match these designs to populate your own magical garden with unique floral doodles inspired by nature.

Whether you already love drawing, or have never thought of yourself as someone who can draw, you'll enjoy expressing yourself with FloraBunda. Then use markers, colored pencils, watercolors, or your favorite craft medium to transform your inky doodles into exotic, lively art.

Get the definitive reference:

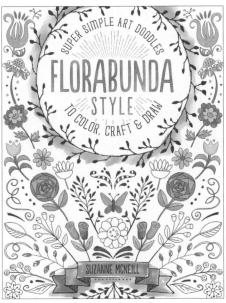

FloraBunda Style
$19.99 • Code: DO5526

Plus two fun workbook editions:

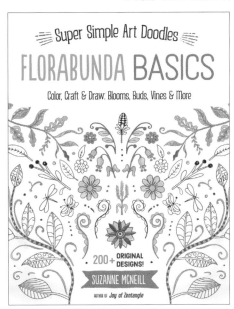

FloraBunda Basics
$12.99 • Code: DO5527

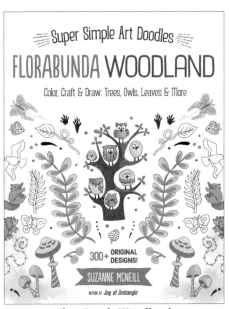

FloraBunda Woodland
$12.99 • Code: DO5544

- Learn to draw fun, nature-inspired doodles
- Simple shapes for flower petals, buds, leaves, vines, and more
- Perfect for markers, colored pencils, watercolors, embroidery, and crafts
- Draw right in the books—they're printed on high-quality artist paper
- Relax and reduce stress while you create unique, beautiful art

DESIGN ORIGINALS

By Phone: 800-457-9112 • **Direct:** 717-560-4703
Fax: 717-560-4702
Online at: www.FoxChapelPublishing.com
By Mail: Send Check or Money Order to
Fox Chapel Publishing
1970 Broad St.
East Petersburg, PA 17520

US

# Item	Shipping Rate
1 Item	$3.99
Each Additional	.99

VISA
MasterCard
DISCOVER NOVUS

Canadian & International Orders - please email info@foxchapelpublishing.com or visit our website for actual shipping costs.

CONTRIBUTORS

Kati Erney

Kati Erney works on staff at Design Originals in the book editorial department, where she spends a surprising number of hours crafting. She loves to color in vibrant hues and striking, symmetrical patterns. Some of her favorite things include reading books and creating art for home decoration, which makes working at Design Originals a dream.

Valentina Harper

Valentina Harper is the author/illustrator behind the best-selling Creative Coloring series. One of her titles, *Creative Coloring Inspirations*, has climbed to the top of *Amazon.com* and other publishing charts. The Venezuelan artist spends countless hours creating her signature uplifting messages and intricate designs from her studio in Nashville, TN. www.valentinadesign.com

Suzanne McNeill

Suzanne McNeill is the author of more than 30 best-selling books, including *Joy of Zentangle*, *The Beauty of Zentangle*, *Zentangle Basics* through *Zentangle 12*, and *Zen Mandalas*. She is a designer, author, columnist, art instructor, and lover of everything hands-on. Suzanne founded Design Originals (an imprint of Fox Chapel Publishing), the leading publisher of Zentangle books. She received the "Lifetime Achievement Award" from the Craft & Hobby Association. blog.suzannemcneill.com / www.SparksStudioArt.com

Llara Pazdan

Llara Pazdan works on staff at Design Originals, crossing into many departments from editorial to design. With a background in advertising, her passion for all things crafting has brought her artwork away from the computer screen and back into her marker-stained hands. She enjoys being outdoors and exploring antique markets for craft/upcycle ideas, which she loves to share here at DO.

Angela Van Dam

Angela Van Dam is a professional graphic designer. She is the owner/artist/designer at Hello Angel, where she creates art for fun, love and money! Angela is a Kiwi, that is to say, a New Zealander from waaaay down there at the bottom of the world. This dynamic art illustrator and her family live in Wanganui, New Zealand, although they have hopped between NZ and Australia several times in the last few years. www.helloangelcreative.com

Amy Anderson

Amy Anderson is the blogger behind the popular websites Mod Podge Rocks and Washi Tape Crafts. Winner of a Bloggie award for Best Art, Craft or Design blog, Mod Podge Rocks has repeatedly ranked as a *Babble.com* Top 50 Crafting Blog of the Year. She wrote the book *Mod Podge Rocks* to commemorate her love of all things decoupage, and her e-books have been downloaded more than 100,000 times. www.modpodgerocksblog.com

Carole Giagnocavo

Carole Giagnocavo is the publisher of Design Originals, one of the world's leading publishers of adult coloring and meditative drawing books. Carole is one of four Certified Zentangle Teachers (CZTs) who are part of the Design Originals team. In her family she is known for seeing Zentangle patterns wherever she goes, from tree bark to covers on manholes. Her teenagers respond, "Yes, Mom, I see the tangle," followed by a long sigh. She enjoys gardening, cooking, traveling, reading, and doing craft projects with whatever spare time she has.

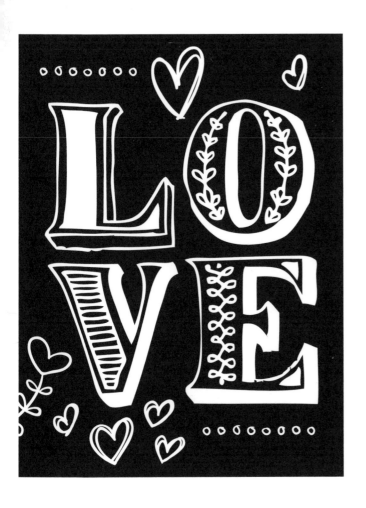

In Life it doesn't MATTER WHERE YOU ARE GOING it's WHO you have around YOU ON THE Journey.

It's the moments together that change us forever.

—Unknown

Be happy for this moment. This moment is your life.

—Omar Khayyam

Just living is not enough. One must have sunshine, freedom, and a little flower.

—Hans Christian Anderson, *The Butterfly*

Grow old along with me
The best is yet to be

—Robert Browning, *Rabbi Ben Ezra*

What's meant to be will always
find its way.

—Unknown

You know, sometimes the world seems like a pretty mean place. That's why animals are so soft and huggy.

—Bill Watterson, *Calvin & Hobbes*

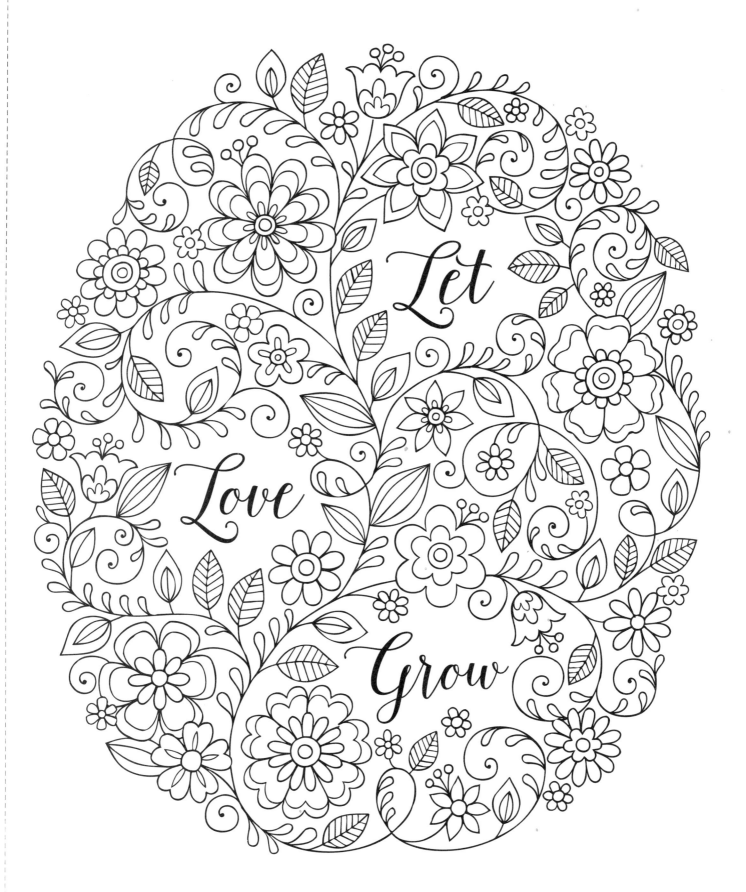

Love is a flower, you've got
to let grow.

—John Lennon

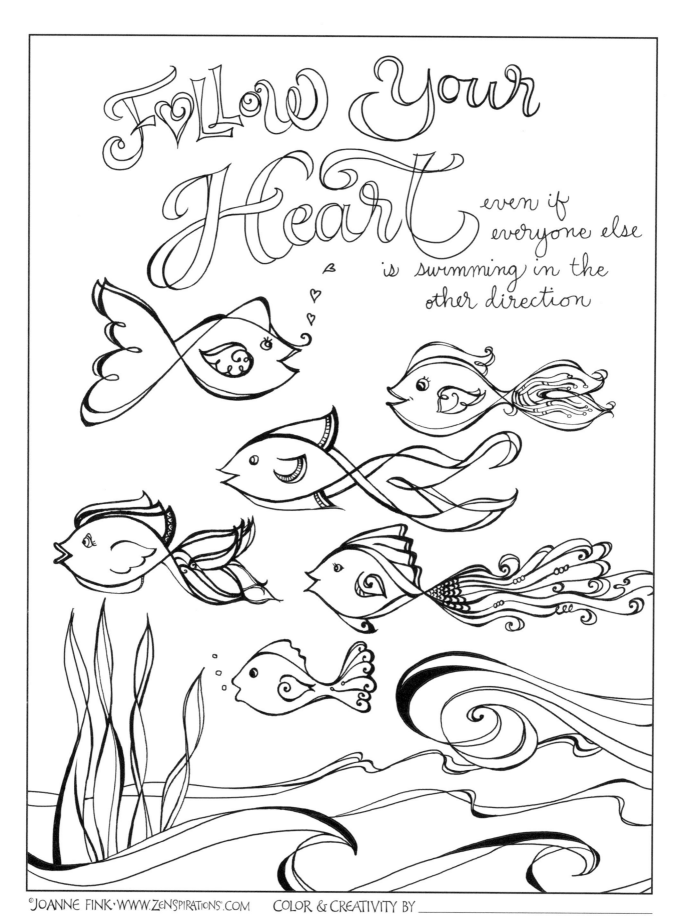

Follow Your Heart even if everyone else is swimming in the other direction

©JOANNE FINK·WWW.ZENSPIRATIONS.COM COLOR & CREATIVITY BY _____

© DO Magazine and Joanne Fink

Why fit in when you were born
to stand out?

—Unknown